IMAGES OF AMERICA

NEW
BRUNSWICK

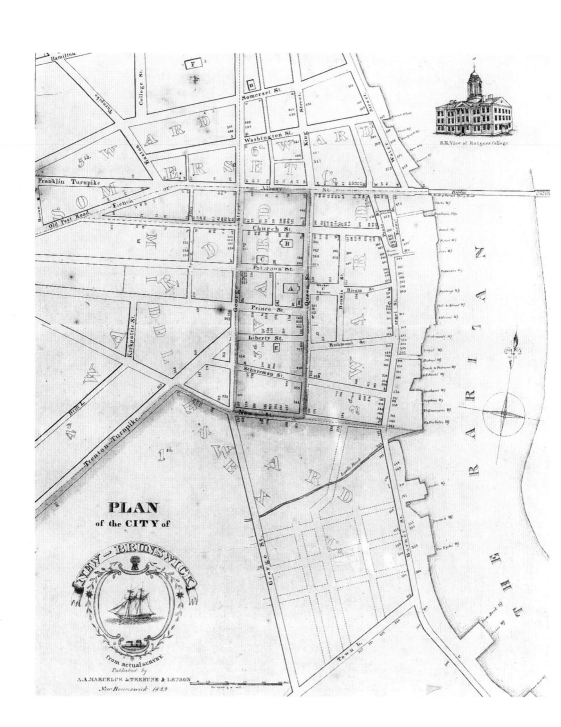

PLAN
of the CITY of
NEW-BRUNSWICK
from actual SURVEY
Published by
A.A.MARCELUS &TERHUNE & LETSON
New Brunswick 1829

S.E.View of Rutgers College

IMAGES OF AMERICA

NEW BRUNSWICK

TIMOTHY E. REGAN

ARCADIA

Frontispiece: New Brunswick in 1829.

First published 1996
Re-issued 2003

Published by Arcadia Publishing
an imprint of Tempus Publishing Inc.
Charleston SC, Chicago, Portsmouth NH,
San Francisco

Printed in Great Britain

Library of Congress Catalog Card Number: 2003107001

For all general information contact Arcadia Publishing at:
Telephone 843-853-2070
Fax 843-853-0044
E-mail sales@arcadiapublishing.com
For customer service and orders:
Toll-Free 1-888-313-2665

Visit us on the internet at http://www.arcadiapublishing.com

Contents

Acknowledgments

In the sometimes overwhelming task of compiling a pictorial history, it is the assistance, guidance, and encouragement of others that bring the project to completion. I am indebted to the following family members, friends, and professionals who made this work possible: my parents, Betty and Gene, and my brother Dan, who have always been by my side and who gave me the love of preserving our past; Larry and Linda Schleicher, who loaned me the needed supplies to reproduce the photographs, and offered their constant encouragement; Dave Galloway, John Reith, and Emile Schettino, who spent countless hours driving around New Brunswick and hearing me ramble about historical things neither they nor I understood at times; Frank Currier, Chris Fox, John Hance, Mike Nelson, Nancy Nelson, John Crabtree, Chris Carpenter, Randy Stout, and Bert Morris; the staff of the New Brunswick Public Library, namely Miss Eugenia Spaulding (librarian), Mr. Isaiah Napier (senior library assistant), and Mr. Robert Belvin (director). I must also extend profound gratitude to the special collections library staff of Rutgers University for all of their help and the use of their images, including the Vanderveer collection. Finally, the biggest thanks goes to my fiance Patricia Schleicher, who spent many late hours typing, correcting, and assisting me with every facet of this work. Without her this book would have not succeeded. Thank you Patti.

Introduction

What I have complied in this work is a small cross section of the people, structures, and history that were nurtured and grown in the City of New Brunswick from about 1681 until the early part of the twentieth century. To attempt a complete history of the city would be foolish and repetitive, for two excellent sources of city history already exist: *New Brunswick in History*, and John Walls' *The Chronicles of New Brunswick*. Much of the information in this book was borrowed from these two volumes and without them this work would have been impossible to complete. The following is a brief history highlighting the city's progress and prefacing the fine photographic record which is to follow.

During the last half of the seventeenth century, the area that was to become metropolitan New Brunswick was no more than a Native American village and some swampland along the Raritan River. The first recorded European inhabitant of the area was a man named Daniel Cooper, who resided near the present site of the Albany Street bridge approach. Mr. Cooper operated the ferry that was later purchased by John Inian; the area became known as Inians Ferry as early as 1713.

In 1730 Mr. Inian finally acquired some neighbors, a group of about fifty or so Dutch families who had emigrated from Albany, New York. They settled along French Street, which soon became known as Albany Street in honor of its primary residents' hometown. Soon after the small town received the name of New Brunswick as a tribute to the Royal House of Brunswick in England. William Burnet and a few other concerned citizens applied for the first city charter in 1736; this recognition was soon granted and New Brunswick became an official settlement. By 1745, the city consisted of Albany Street, the primary residential area; Burnet Street (named in honor of William Burnet), which became the commercial center; and a few other roadways including King and Queen Streets, which later became Neilson, George, Little Burnet, and Peace Streets. The small town quickly established itself as a shipping port, taking full advantage of its location along the Raritan River. By 1748, the town's rapid development caused a

Swedish traveller to remark, "I never saw any place in America, the towns excepted, so well peopled." Along Burnet Street (which today lies beneath the Memorial Parkway section of Route 18), small storehouses abutted the river banks, and schooners and tall ships left daily for New York City and other ports abroad. Soon hotels such as the VanVoorhuise House (later known as the Vanderbilt House) were erected, providing accommodation for travelers.

New Brunswick played an important part in our fight for independence. Several small fortifications were erected around the town between 1774 and 1778. Hessian, British, and Loyalist troops were all camped in the small town during various intervals. Also, small skirmishes were common with several casualties being reported on all sides.

After the Revolution it was time to begin rebuilding what the British had burned or plundered, and by 1799 the city was well on its way to success. Merchants began opening shops on every corner and every lot between. Some of the stranger items that were being sold in 1800 included knee and shoe buckles, bellows and snuffers, and such dry good items as rattinets, calamancoes, shalloons, peelongs, and moreens. The merchants of New Brunswick were stocked with every item one could need. During the mid-1850s the city was dubbed "The Hub," as it was the center of all affairs in the Raritan and Millstone Valley region. The city became the Middlesex County seat in 1793, after a bitter fight with the City of Perth Amboy. By 1828, five thousand people called New Brunswick home and that number grew until the present population figure of about 45,000 was reached in the mid-twentieth century.

No history of the city would be complete without a mention of Rutgers College. Formed as Queens College in 1766, the college opened in 1771 and in 1774 the first class graduated. In 1825 the name of the school was changed in honor of Colonel Henry Rutgers, who was a generous benefactor to the institution. Today Rutgers includes Cook College, Douglas College, and several other campuses in New Brunswick, Piscataway, Newark, and Camden.

Like many American cities, New Brunswick was not immune to the economic decline of the post-World War II years. By the 1950s, most of downtown New Brunswick had fallen into disrepair, since the average building in that area was built before 1830. Controversy developed regarding the necessity of updating the city's architecture. "Spare that ancient house, touch not a single stone," were the words written by Mayor John B. Hill in the 1855 city directory. Mayor Hill, who was an avid historian, was far ahead of his time with his thoughts of historical preservation. The good mayor had no idea how significant his statement would become; nearly one hundred years later the city that Mayor Hill knew would be entirely demolished by the Gerber Wrecking Company for the construction of NJ Highway 18. Although the last nineteenth-century building stood on Burnet Street until early 1993, the area has been generally redeveloped. New Brunswick is a city of lost history, and it is hoped that the reader will use this book as a beginning to learn more and discover this "Hub City's" wealth of lost history. Please excuse my errors.

Timothy E. Regan
March 1996

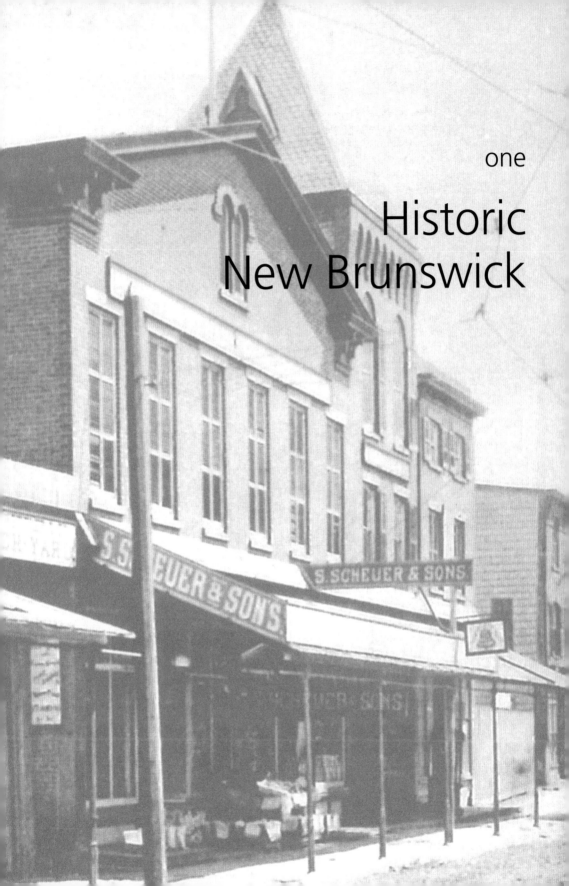

one

Historic
New Brunswick

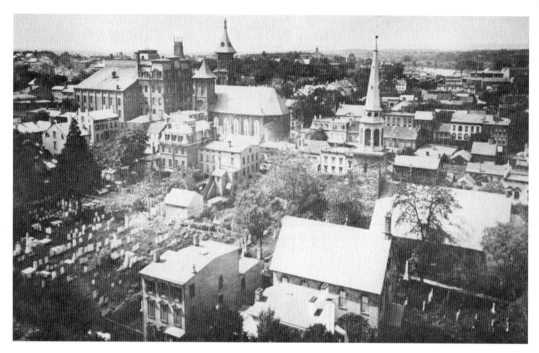

New Brunswick from the Reformed Church in 1884.

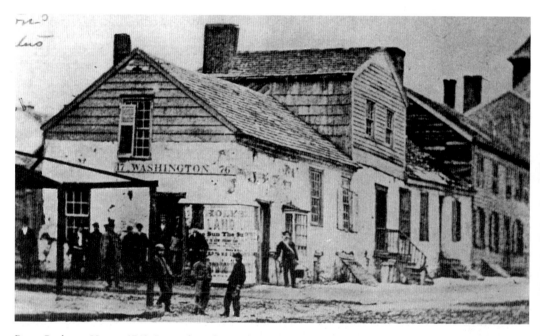

Peter Cochrane House, 1742. Located on the southwest corner of Albany and Neilson (Queen) Streets, this structure was the site of the reading of the Declaration of Independence on July 9, 1776. It was used as General Charles Lee's prison; the British Colonel John Simcoe was also held prisoner here. The long, low, moss-covered structure was one of the oldest in the city. Through the years it was also known as LeGranges Stone House, Mariners', Jaques', Suttons', and others.

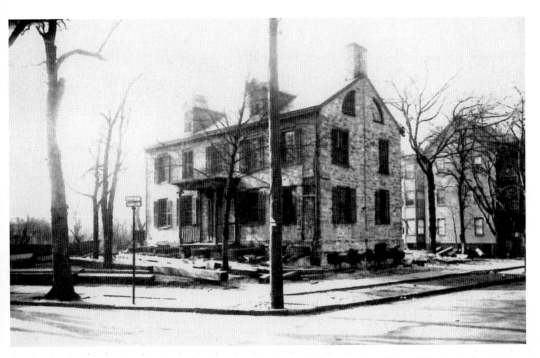

Guest House, 1760. The Guest farmhouse was located on the remote outskirts of the city, where it was constructed before the Revolution by builders Henry and Moses Guest. It is said that author Thomas Paine hid out in this house during 1802. It stood on the corner of Livingston Avenue and Carroll Place (above) until 1926, when it was moved to the library grounds (below) to escape demolition. Today it is kept as a museum and is owned by the free public library. According to tradition, Henry Guest (the "Old Guest" himself) said to his son, "if his descendants would only keep a roof on it, the house would stand 'til Gabriel blew his trump."

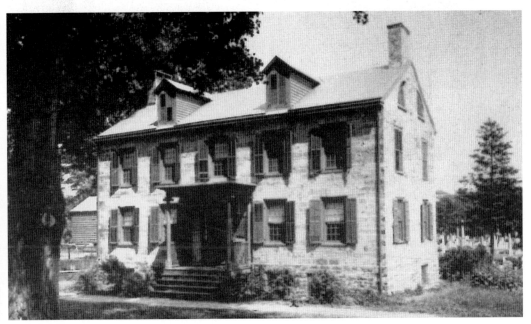

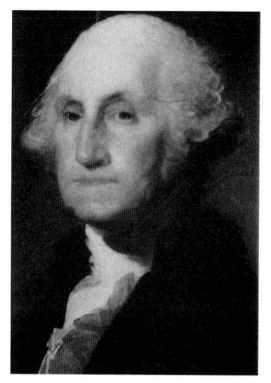
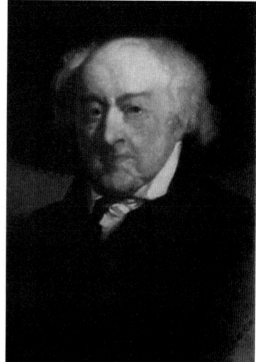

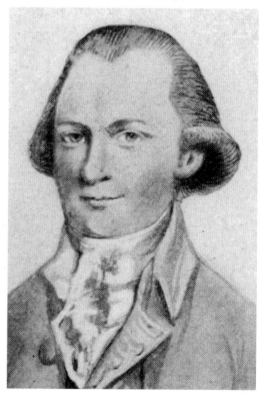

Above left: General George Washington. General Washington first rode into New Brunswick in 1775. He returned again in November 1776, when he met with Lord Stirling. Washington's ventures into the city during the days of the revolution are shrouded with mystery and legend, but it is known that he did stay in several hotels while in the city, including the Whitehall on Albany Street.

Above right: President John Adams. President Adams became the second president of the United States in 1797. He soon journeyed to New Brunswick for business matters and met with his associates in the Whitehall Hotel in 1797. John Adams was one of four presidents who visited New Brunswick during the eighteenth, nineteenth and twentieth centuries.

Right: Colonel Azariah Dunham. Colonel Dunham was born in Piscataway in 1719, and lived in a frame house near commerce square until his death on January 22, 1790. He presided over the town council from 1784 to 1789 and is considered to be the city's first mayor. Although he served in the militia during the Revolution, his belongings—including 218 pounds of sterling silver—were still ravished by the British.

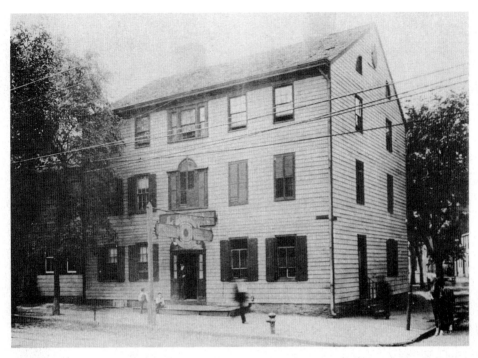

Farquhar House, 1729. Better known as the Indian Queen Tavern, operated by James Drake, this inn was originally built as a one-story house by Dr. William Farquhar in 1729. In 1795, many heated meetings of the New Brunswick Bridge Company, presided over by William Patterson, were conducted in this hall. Standing on the northeast corner of Albany and Water Streets, this building remained the last commercial eighteenth-century structure in downtown New Brunswick until it was finally moved to the Olde Towne Site in Middlesex County's Johnson Park.

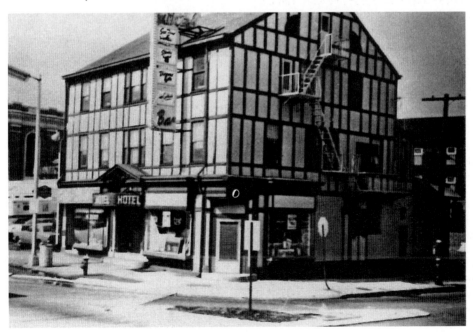

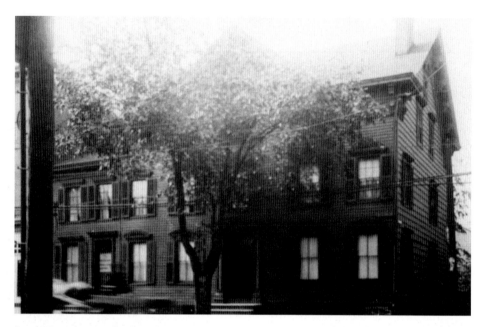

Scott House, 1774. This large frame structure was located on the northeast corner of Albany and Neilson Streets. Built by Dr. Moses Scott, surgeon general of the U.S. in 1776, it was one of the finest houses in the city when it was constructed. It was razed by 1930.

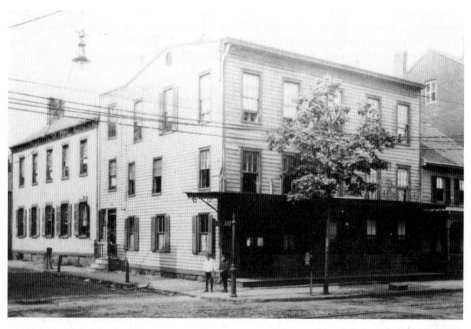

Whitehall Hotel, *c.* 1752. Located on the corner of Albany and Water Streets, this historic inn was the site of General Lee's court martial for misconduct during the Battle of Monmouth in 1778. General Washington was entertained here in 1775, and the sessions of the Provincial Congress were held here in 1776. This plain, three-story wooden structure remained standing until about 1940, when it was removed because of its poor condition.

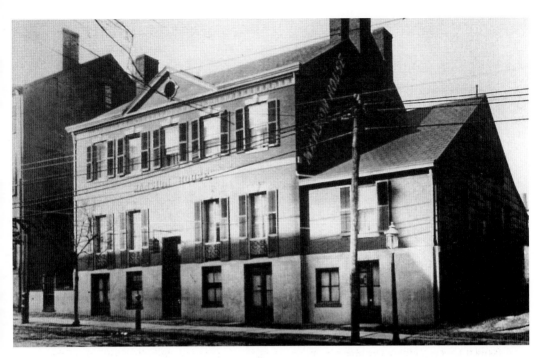

John Bayard House, 1793. John Bayard settled in the city in 1788 and very shortly after built this large, unique brick and frame house on the north side of Albany Street, east of George Street. Bayard died in the house in 1807. After many years it became best known as the Mansion House Hotel, where weary travelers were greeted well into the twentieth century. This structure was unique to New Brunswick with its ground-level entranceway and cast-iron grillwork on the windows. It is possible that the east section of the house was older, due to the dutch-like roof line and shingled walls.

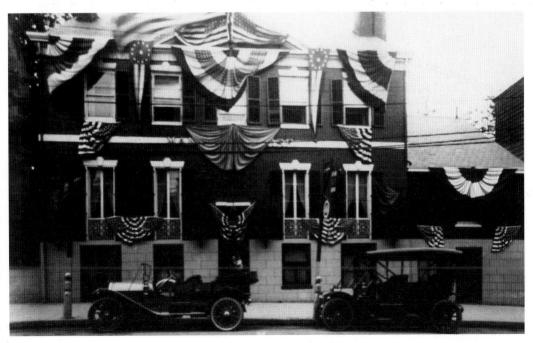

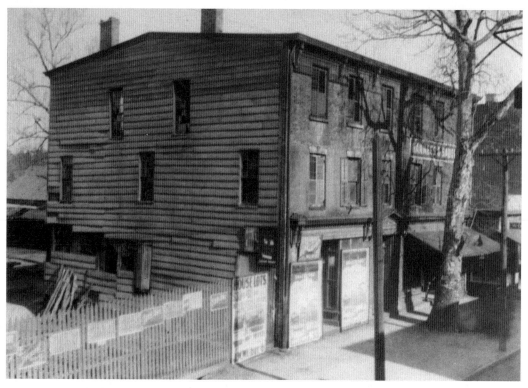

Above: Neilson House, 1733–68. James Neilson rebuilt his home after fire nearly destroyed it in 1768. Until his death in 1783, James lived in the rebuilt house (shown here) with his nephew John. During the Revolution, General Howe of the British forces made his headquarters here from December 2, 1776, until June 22, 1777. This house stood at 265 Burnet Street, which would today place it somewhere in the northbound lanes of Route 18. The house, which was sadly neglected, was razed in 1870.

Left: Neilson House and tree. For many years, the tree fronting the Neilson house was known as the George Washington Tree, for Washington had reportedly hitched his horse to it while in the city. Other accounts list the tree as having served as a flag pole for Lord Howe. During the eighteenth century, a large grassy yard extended from the house into Burnet Street, which was then quite narrow.

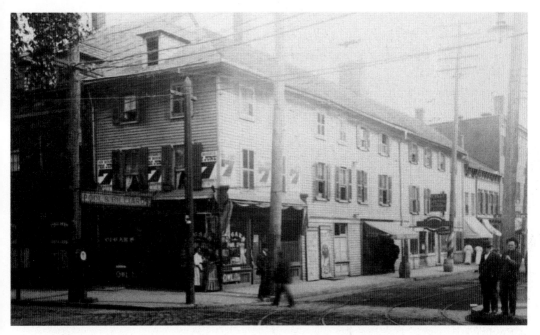

Manns Long Room, 1804. Formerly located at the southeast corner of Albany and Neilson Streets, Mann's Tavern stood until about 1930. Its second-floor assembly room ran the length of the building, which was at least seven times as long as it was wide. The single dormer on the Albany Street side is unique. Today the building as well as the corner has disappeared.

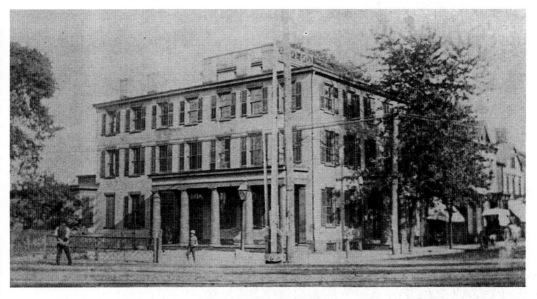

Stelle's Hotel, c. 1845. Benjamin Stelle opened this three-story, Greek Revival hotel complete with an observation deck in the mid-1840s. The hotel, located across the street from the Old George Street Railroad Depot, was host to many prominent travelers well into the early twentieth century. The hotel, later named McCormick's R&R Hotel, was demolished about 1900 to make way for the freight spur of the Pennsylvania Railroad.

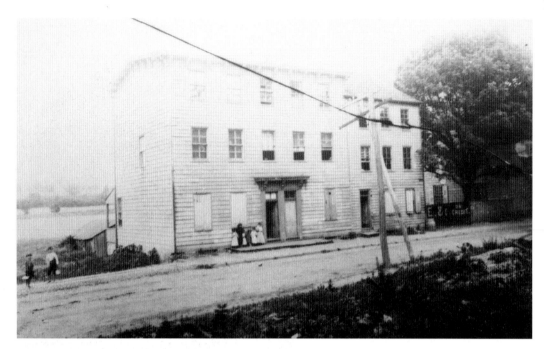

Keyworth's Hotel, *c.* 1804. The widow Nenemiah Vernon married John Keyworth in 1804. The couple soon erected this fine three-story inn overlooking the Raritan River on lower Burnet Street near the steamboat landing. The structure was adorned with a large cupola and lookout during much of the nineteenth century that was later removed due to its weight. The hotel was vacated in the early 1880s and remained vacant until it was demolished in February 1930. It was the first steamboat hotel erected in the city.

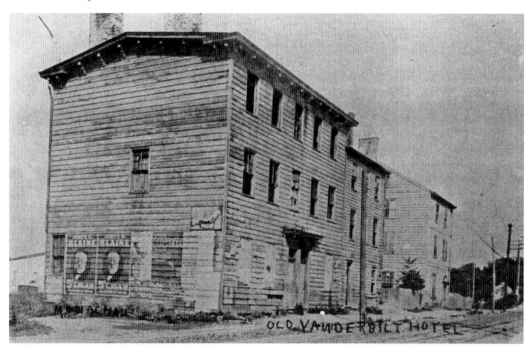

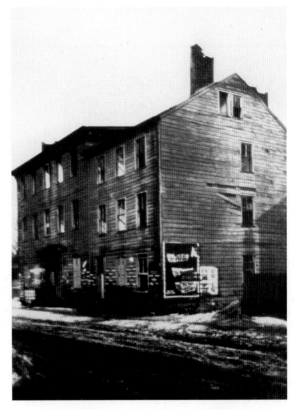

Right: Keyworth's Hotel, 1930. This 1930 photograph was the last ever taken of this fine hotel. Once the "traveler's home," the old hotel came to serve only as a large billboard. Look at the myriad of signs and advertisements that adorn the clapboarded walls. This building stood in the center of present day Route 18 just past the George Street overpass.

Below: Vanderbilt's Hotel, 1814. Located next door to Keyworth's Hotel, this building was built by James Murphy in 1814. According to *The Chronicles of New Brunswick* (1930), Corneilus Vanderbilt, "presented a petition praying license to keep a public house of entertainment for the ensuing year where he at present dwells, " and his prayer was answered. Mr. Vanderbilt later named the hotel "Bellona" after his steamboat. The hotel stood windowless and forgotten until razed in 1906.

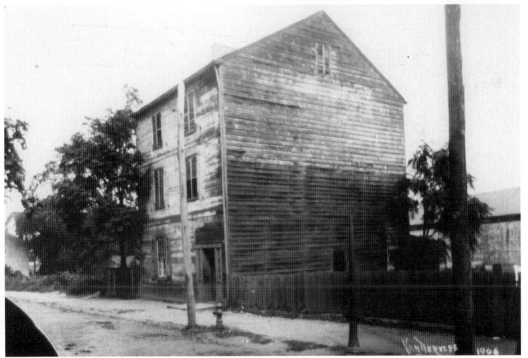

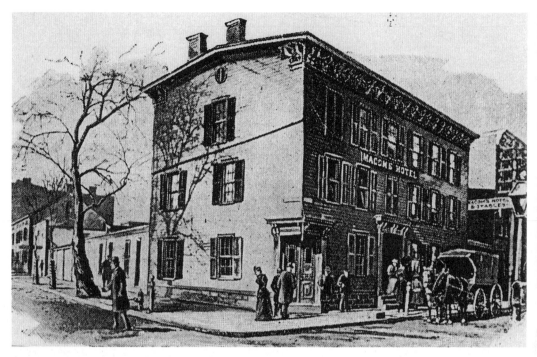

Macom's Hotel, *c.* 1820. These two images illustrate the deterioration of a fine, three-storied stopping place to an empty hulk stripped of elegance and charm. Macom's hotel once stood on the northwest corner of Burnet and Richmond Streets, but was demolished in the late 1970s. During its time it was one of the finest hotels in the city.

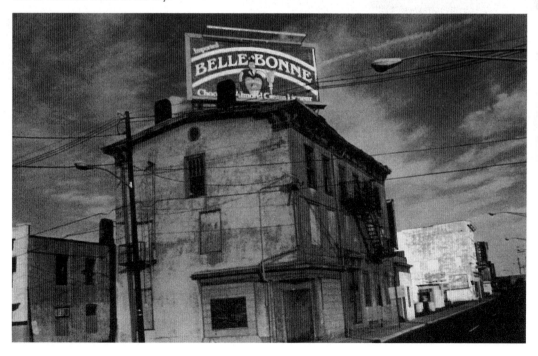

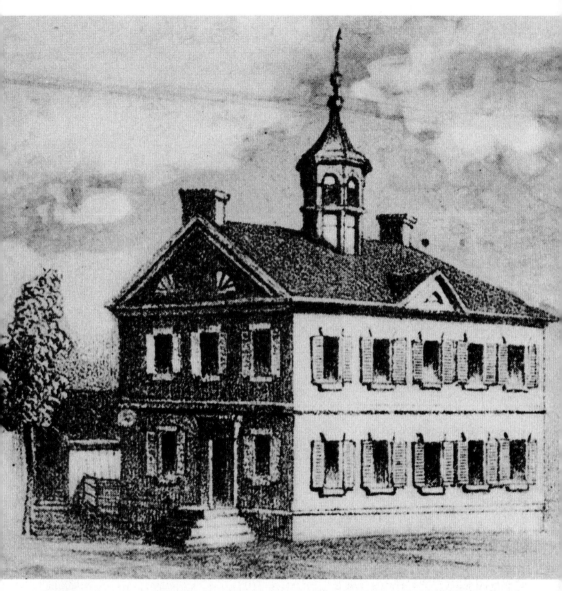

Third Courthouse and City Hall, 1796. The third courthouse and city hall was built by John Plum and Elijah Philips on land donated by John Dennis. This courthouse, also known as Union Hall, was constructed in the Georgian style and measured 45-by-35-by-20 feet. This structure replaced the second courthouse, which was destroyed by fire in 1796. Union Hall was located on Bayard Street near Neilson.

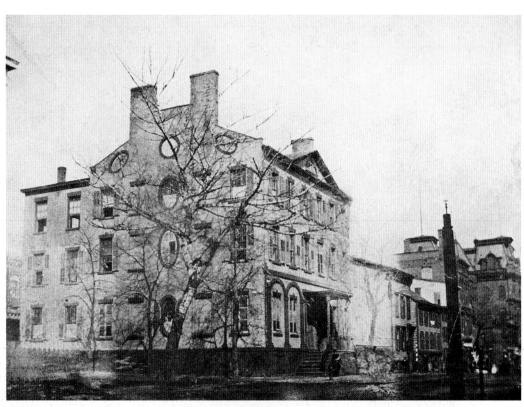

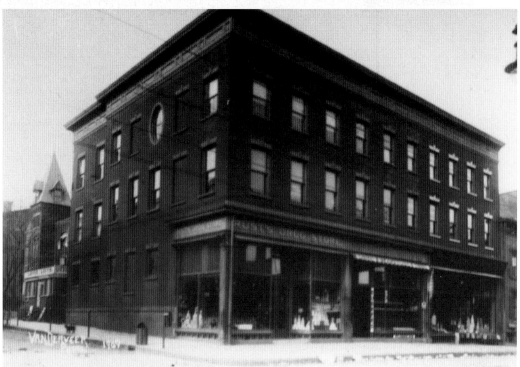

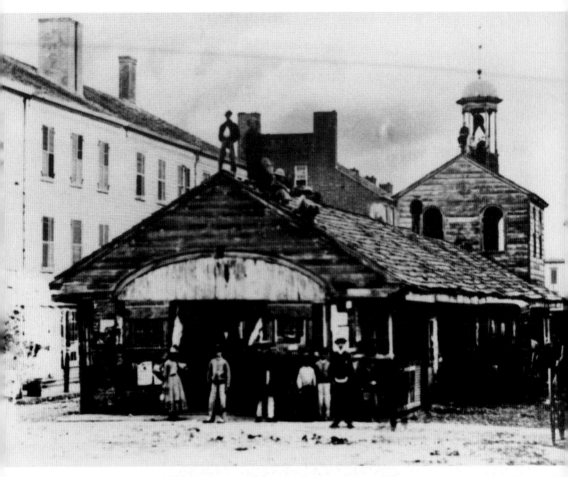

Above: Third City Market House, 1811. From 1811 to 1865, this structure served as the city's main area for farmers to display and sell their produce. It consisted of the long low structure in the foreground and the two-story section containing offices and a cupola for the fire alarm bell. By 1855, about the time of this photograph, the building was considered an eyesore to the inhabitants. The market house was built by the firm Low and Voorhees and cost $1,899 to finish. It stood in the center of Hiram Street across from the Reformed Church.

Opposite: Bank of New Brunswick, 1814. Influenced by French design, this ornate Greek Revival structure was opened in the fall of 1814 on the corner of George and Paterson Streets. The Bank of New Brunswick was the third bank chartered in the state. The bank closed in 1834, when it became the Mansion House Hotel. By 1847, the hotel closed and was purchased for $5,750 by Miss Hannah Hoyt for her young ladies' school. At the turn of the century, the structure was dramatically altered and reopened as Rust's Drug Store, and it remained as such until it was destroyed in mid-1960s. Note the sole remaining oval window in the photograph below; it was once one of five such openings in the structure. Buildings along the smaller streets also contained these oddly shaped windows.

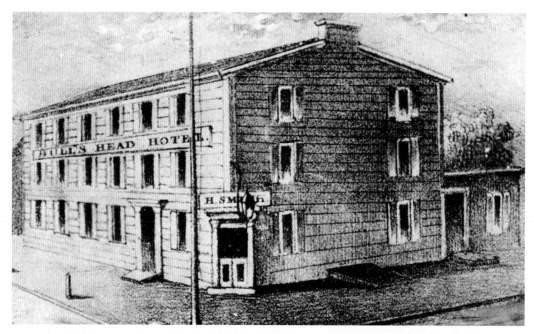

Bull's Head, *c.* 1800. It was from the Bull's Head that on February 7, 1849, a group of men known as the forty-niners headed to the barque *Isabel* to sail for California gold from the New Brunswick wharf. No one from New Brunswick is known to have struck gold, but many such parties struck out from the old inn. The Bull's Head was located near the corner of Hiram and Burnet Streets, and was built *c.* 1800. Damaged by the infamous 1835 tornado that killed three persons, it was later rebuilt, but was finally demolished in 1876.

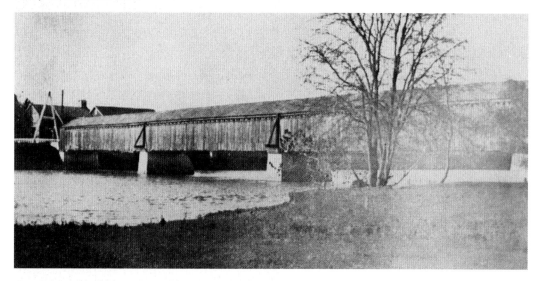

Covered Landing bridge, 1773. "The Landing" area of New Brunswick, in the northeast corner of the city, was settled quite early. Since fording the river was quite difficult because of the deep tides, residents in 1773 decided to construct a covered bridge. The bridge contained three sections and rested on four stone piers. It remained standing until February 18, 1894, when it was destroyed by fire. The reconstructed bridge that stands presently was built at that point.

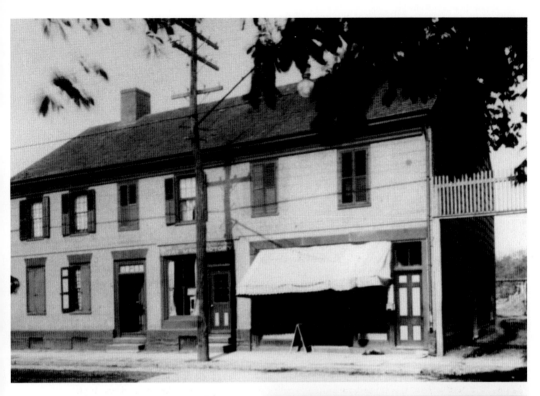

Above: Schureman House, *c.* 1790. This house was constructed in the characteristic Dutch style of brick facade with clapboard and shingled side and rear walls. Written on the back of this photograph is "Schureman House, Burnet Street." According to history, however, the Schureman family lived near Three Mile Run southwest of the city on the family farm, and only kept a storehouse on Burnet Street. The house was demolished in 1951–52 along with much of Burnet Street.

Right: James Schureman, born 1756. One of the most famous natives of New Brunswick, Shureman served in several positions at Queens (Rutgers) College, and later fought with Colonel Neilson in 1776. He lost one eye to small pox in 1801. Schureman was elected mayor of New Brunswick in the same year, and served until 1813. He was elected again in 1821 and served until 1824. The honorable public servant died on January 22, 1824; a street was later named in his honor, although it no longer exists.

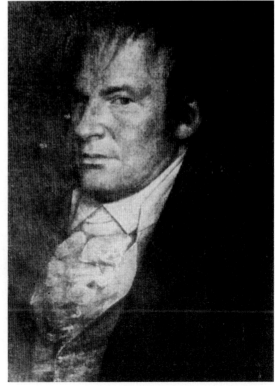

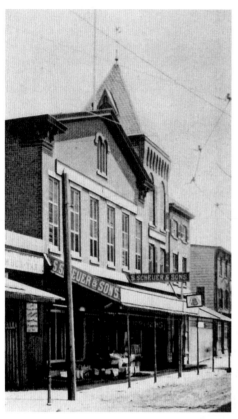

Left: Greer's Hall, 1853. Mr. George Greer opened this building at 283–287 Burnet Street in October 1853. In the last half of the nineteenth century, this building's second floor served as an amusement hall and the social center of the entire city. The ground floor was occupied by several tenants; Scheurer and Sons Grocery Store was established there for the longest period of time. During both the Civil and Spanish-American Wars, Greer's Hall was an army recruiting site.

Below: Greer's Hall. By 1951, the omnipresent "Gerber Wrecking Company" sign was affixed to Greer's Hall. The Gerber Wrecking Company was hired to clear most of the buildings located on the south side of Burnet Street, and all of the buildings on the north side, including Greer's Hall. This project, which resulted in Route 18, would forever change the city and demolish its historic district, which in 1951 was considered an impediment to progress.

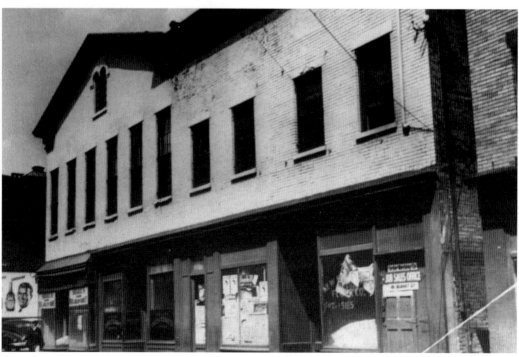

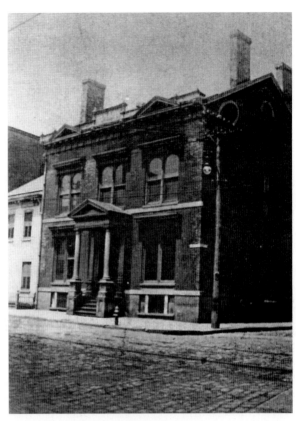

Left: State Bank, 1815. The act to incorporate state banks in New Jersey was passed in 1812. Soon after, New Brunswick opened its State Bank at 39 Albany Street under the leadership of Asa Runyon, Squire Martin, and H.V. Low. By 1815, a larger bank building was constructed on the corner of Albany and Peace Streets. The bank closed its doors in 1877, due to a large debt which could not be paid. The building itself stood until the mid-1970s.

Below: National Bank, *c.* 1870. The Bank of New Jersey (organized in 1837) was restructured in November 1864 as the National Bank with a starting capital of $250,000. The fine bank building was located on the corner of Church and Neilson Streets and was vacated in 1910, when the bank moved into its new eight-story home on the corner of George and Church Streets.

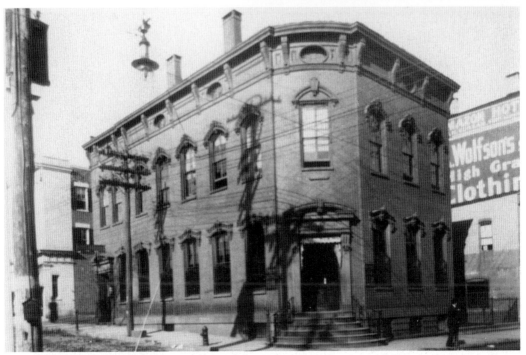

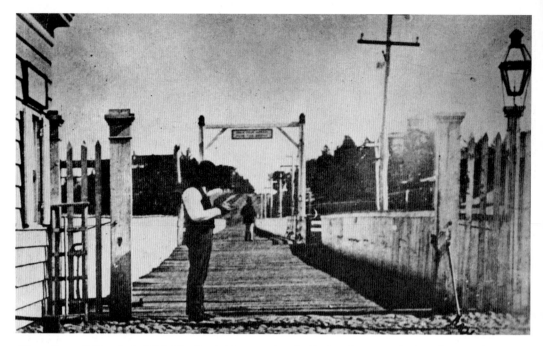

Albany Street Bridge, built 1794. The first bridge spanning the Raritan River was built at the site of John Inians' Ferry at the foot of Albany Street. The bridge remained standing until 1841 when it was closed by the Camden Amboy Railroad (see p. 110). In 1851, the bridge was rebuilt and remained a toll bridge until 1876. It was removed *c.* 1925 and replaced with a new stone structure.

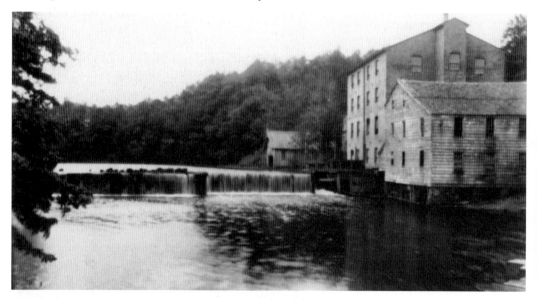

Gristmill, *c.* 1750. The old wooden gristmill was built around 1750 near the southeast corner of the city along the Lawrence Brook. In later years it was converted into a textile mill that made clothing and fabric from the local supply of wool. In 1839, Mr. Edergerton purchased the property and began making tobacco snuff. It continued being used for this purpose into the twentieth century, until it was destroyed.

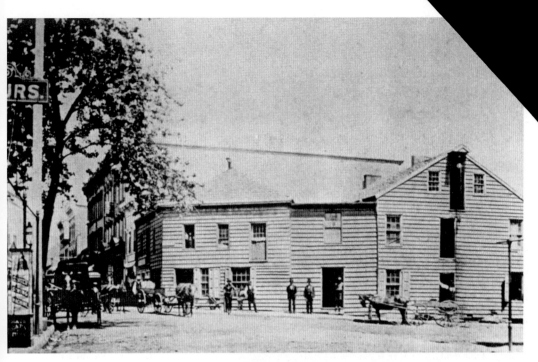

Above: Commerce Square, 1873. At the center of this photograph is the Iron and Tin Shop of George H. Stout and Sons, which opened on July 9, 1827. This factory and storehouse stood at the foot of Burnet Street and was flanked by Peace Street to the west and Little Burnet Street to the east. Commerce Square was the original site of the first city market and courthouse, which was erected in 1776–78. The site is now part of Route 18.

Right: Commerce Square, 1873. In sharp contrast to existing structures in the above photograph, the Stout family erected a large Italianate showroom and office at the foot of Burnet Street in 1873, replacing the older frame structure. This building stood into the 1970s and, although stripped of its ornamentation, remained one of the finest storehouses in the Burnet Street area.

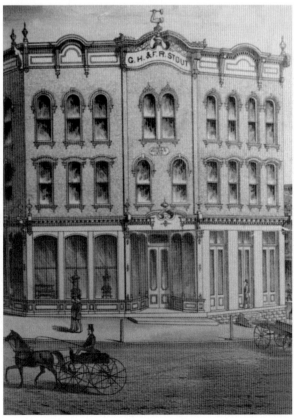

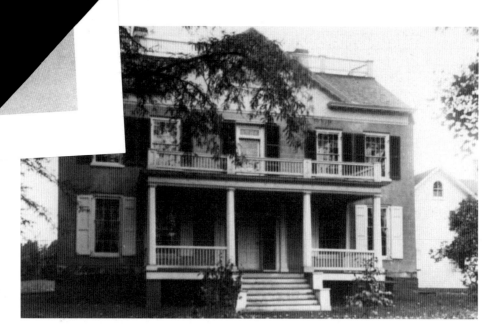

White House/Buccleuch Mansion, 1739. Located at the far northwestern side of the city is the White House or Buccleuch Mansion. Built by Anthony White between 1739 and 1740, the White House is a classic example of Georgian architecture, and has an 1830s addition. The house was occupied by British General William Burton from 1774 to 1776. It passed through several hands before finally being purchased by Joseph W. Scott in 1821. It remained in the Scott family until 1911, when several of his descendants—including Anthony J. Dey—deeded the property to New Brunswick for use as a public park. Today the house is operated by the Daughters of the American Revolution as a museum, and Buccleuch Park remains a quiet area of 80 acres between Easton and George Streets.

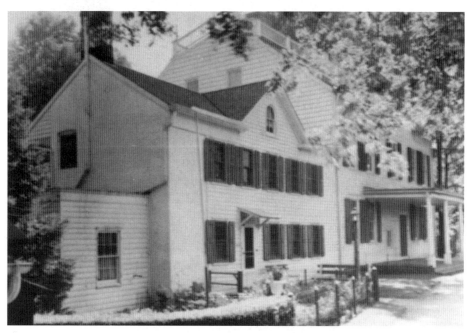

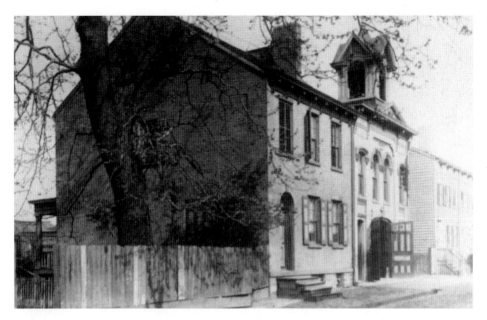

Andrew Agnew House, c. 1760. "Simplistic Federal Style" could describe the Agnew house, which stood on the east side of Burnet Street next to the Washington Engine Company House. At the rear of this house along the banks of the Raritan a midnight skirmish occurred on January 4, 1782, in which five British soldiers were killed and five Americans were wounded. The house itself was razed in 1951, after standing on Burnet Street for more than a century.

Captain Gibb House, c. 1770. This historic Burnet Street house stood near the Agnew house. Built by Captain Gibb in the 1770s, the house was later occupied by local distiller John Hicks. Its most noted tenant, however, was William H. Vanderbilt, who became a legend in American railroad development. William was born at 181 Burnet Street on May 8, 1821. This house with its brick front and wooden sides remained standing until the mid-twentieth century.

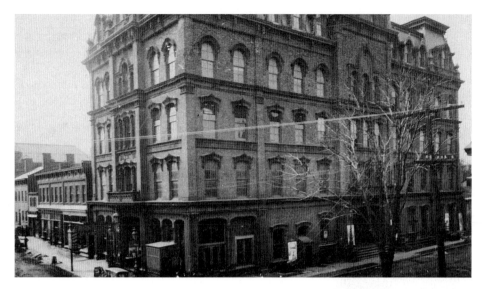

Masonic Hall, 1871. Designed by Augustas Hatfield and modeled after the plan of Philadelphia's City Hall, this edifice was once the most elaborate of all buildings in the city. When completed, the mansard-roofed giant contained the Opera House, offices for various clubs and businesses, and the post office. It stood on the southwest corner of George and Albany Streets until being totally destroyed by fire on December 21, 1896. Note how the structure dwarfs the surrounding buildings.

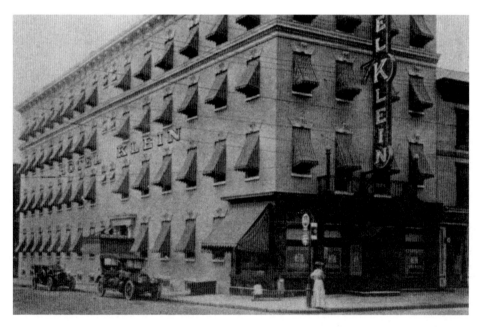

Jackson House, c. 1850. The Jackson House was one of the first brick hotels in the city when it was completed in 1848–50. The hotel conducted business at its prime location of the corner of Albany and Little Burnet Streets until about 1920, when it was remodeled as the Hotel Klein. During reconstruction a third story was added and rooms were refurnished throughout. It stood until c. 1967.

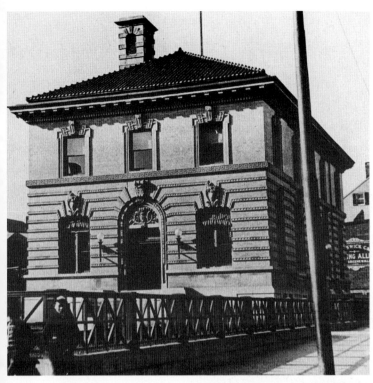

United States Post Office, 1901. After the Masonic Hall fire of 1896, the new post office was erected on the same site by 1901. The building was modeled after a renaissance palazzo and contained a courtyard and parking area on the east side. Additions in 1911 and 1923 expanded the structure and removed the courtyard in the foreground. The building was destroyed by 1970.

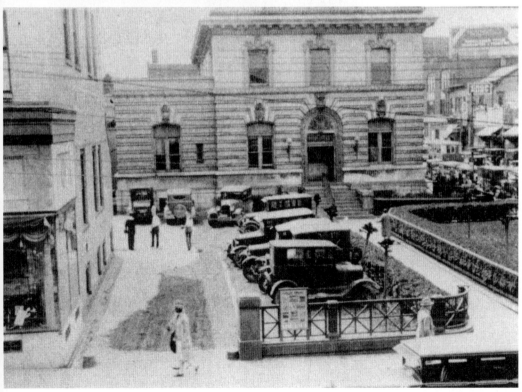

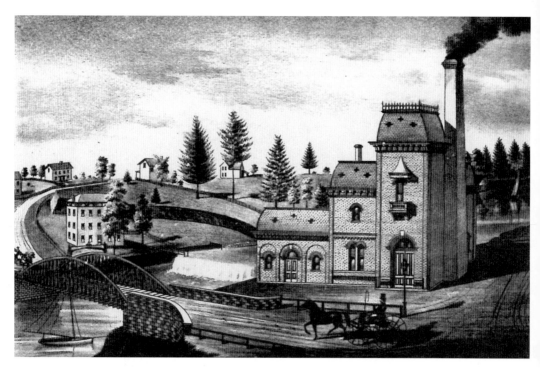

City Water Works, 1867. Water first flowed to the streets of the city in 1801. The Fountain Company had installed hollowed-out logs which were to carry water from the Barrack Spring on Church Street down Albany Street. The project failed and not until 1863 did the subject "spring up" again. By 1865, the city voted to establish a fine water works at the site of Hercules Weston's mill, along the Lawrence Brook on lower Burnet Street.

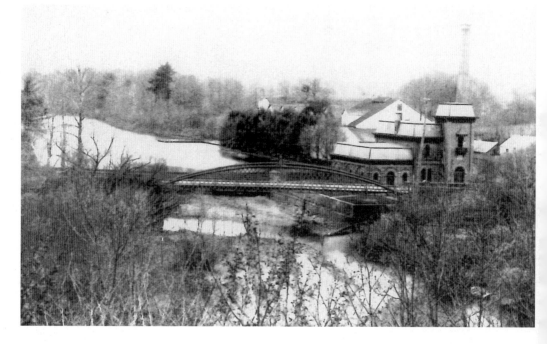

two

Education

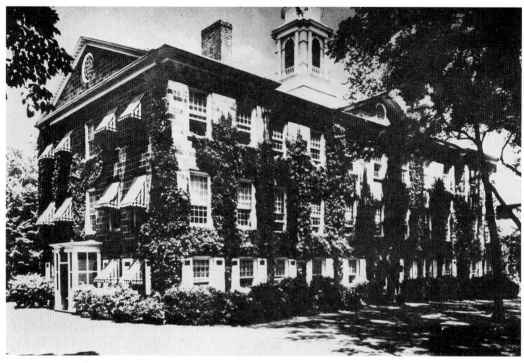

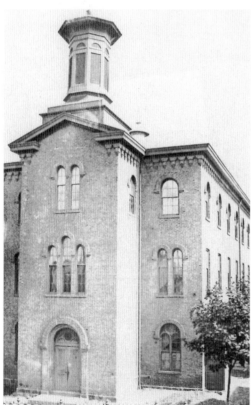

Above: Queens College Hall, 1808.

Left: Bayard Street School, 1851–53. New Brunswick taxpayers had no public school system until 1851. Before this date, wealthy children attended private schools and the poor were educated at the Lancasterian School (see p. 38). In 1850 local druggist Charles P. Deshler brought the idea of the public school system back from New York City. Soon after, the lot on Bayard Street between Neilson and George Streets, where the old barracks and jail stood, was procured for a school. John Hall was paid $100 to design this three-and-one-half-story brick structure, which opened in 1855. In 1893 the front four rooms were removed; in 1895 twelve new rooms were added and the cupola was removed. The building is still used as a school and remains one of the oldest occupied edifices in the state.

Right: Livingston Avenue High School, 1876. In 1870, homeowners on Livingston Avenue opposed the construction of the first high school because they wanted to maintain a strictly residential community. By 1875, the battle had been lost and the first high school was dedicated on May 4, 1876. This extremely ornate Italianate structure served as the city's high school until 1914, when the new high school was built. It was demolished *c.* 1930 to build the Roosevelt Junior High School.

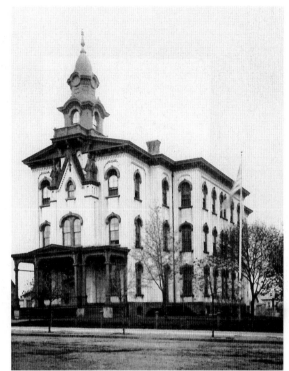

Below: Hale Street School, 1872. The only school in New Brunswick history to be built for African-American students was the Hale Street School. In 1882, the practice of maintaining separate schools for African-Americans was terminated. The school was named after Nathan Hale, the martyr/spy whose famous last words were, "My only regret is that I have but only one life to give for my country."

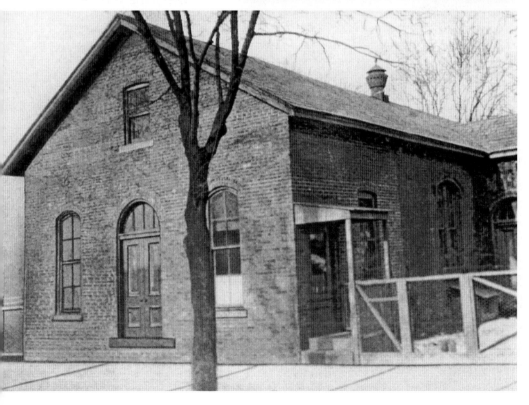

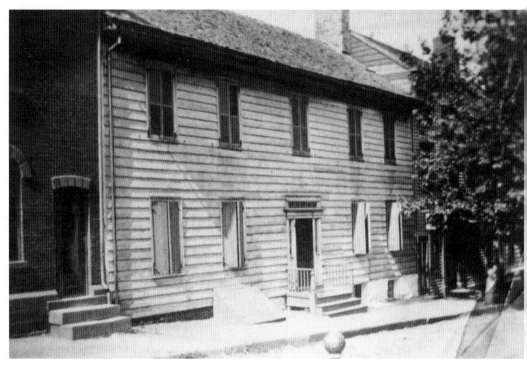

Above: Queens College, *c.* 1773. One of the first buildings occupied by Queens College was this plain frame structure. It originally stood at the present site of Monument Square on George Street. Queens College graduated its first class in this building in 1774. By 1808, enrollment surpassed this structure's capacity and the college moved to its present site on Somerset Street.

Left: Queens College. In 1803, $4,000 was deeded by William Hall to Thomas Grant and his son Ebenezer for the purpose of educating the poor children of the city. In 1813, after Queens College vacated this building, it was bought by the Lancasterian School for $450 and moved to Schureman Street across from its original site. Finally, on April 6, 1814, the school opened with thirty-five free and six paying pupils. Mr. Shepard Johnson became the first teacher at a salary of $150 per year. This school remained at the same spot until 1879, when it closed. In 1905, an addition to the Liberty Hose Firehouse on George Street reduced the school by a third, creating the evident change in the two views.

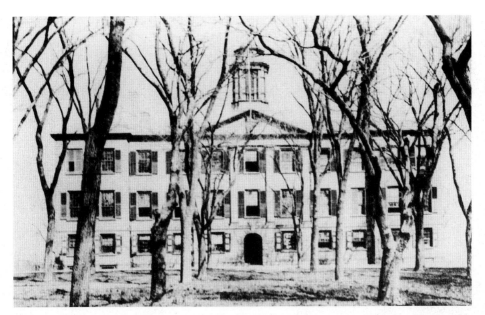

Queens College building, 1808. Queens College Hall (or "Old Queens") was built by John McComb, the same architect who designed the city hall of New York City. The 5-acre parcel of land used as a site for the building was a gift of the James Parker estate in 1808. When constructed, this edifice housed all the college's necessities: dormitories, classrooms, administrative offices, rooms for the professors, and also the theological seminary. Old Queens, which stands in the center of the campus grounds, is the most beloved of all Rutgers structures. During the late eighteenth and nineteenth centuries, Queens College architecture was characteristic of American college design; similar buildings were also constructed on the campuses of Princeton and Yale. Today the oldest bell in Middlesex County hangs in the cupola of Old Queens.

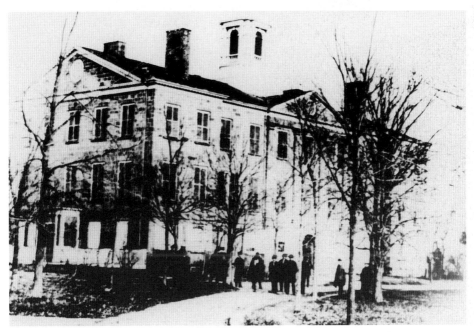

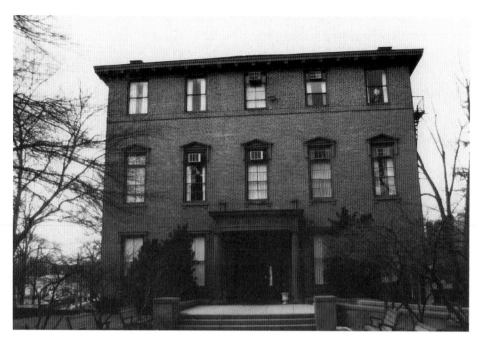

Van Nest Hall, 1847. Named after Abraham Van Nest, this three-story classroom building was built on the slight bluff at the northwest corner of the campus grounds. The structure has only been slightly altered since its construction and still serves as an active college building.

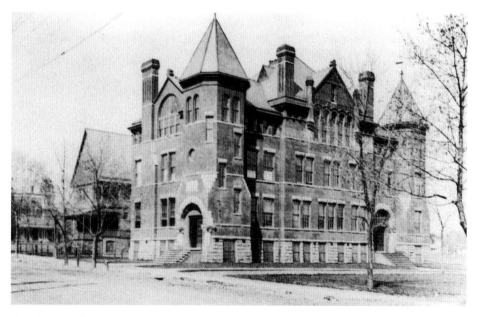

New Jersey Hall, 1889. Erected by the State of New Jersey in 1889, this structure was intended primarily as an agricultural experiment station. The land it stands on was donated by James Neilson, and the building itself cost $40,000 to complete. It was the first of many buildings to be completed on the Neilson campus, which is bounded by Hamilton Street, George Street, and College Avenue, as well as Seminary Place.

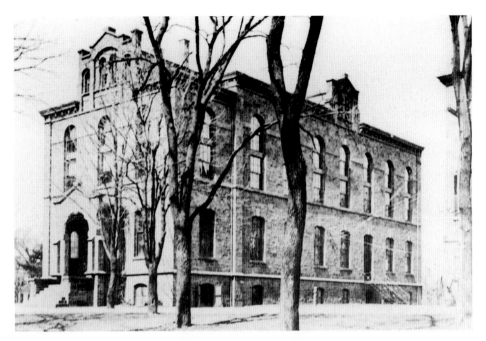

Geological Hall, 1870–71. H.J. Hardenbergh designed the fifth structure to occupy the campus green. This structure, which was built of ashlar to match Old Queens, measured 100-by-40 feet, and opened in 1871. Like the Schanck Observatory and the Kirkpatrick Chapel, it was completed under the college presidency of William H. Campbell.

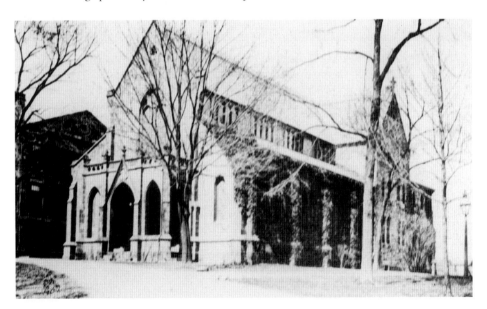

Kirkpatrick Chapel, 1872. The funds to build this edifice were provided by a generous donation from the late Sophia Astley Kirkpatrick. Designed by H.J. Hardenburgh in the Gothic style, it cost over $65,000 to complete. It housed the campus chapel as well as the library. Kirkpatrick Chapel was the last building built for nearly thirty years by the college and was designed to complement Geological Hall. Originally, the library was open only about fifteen hours per week.

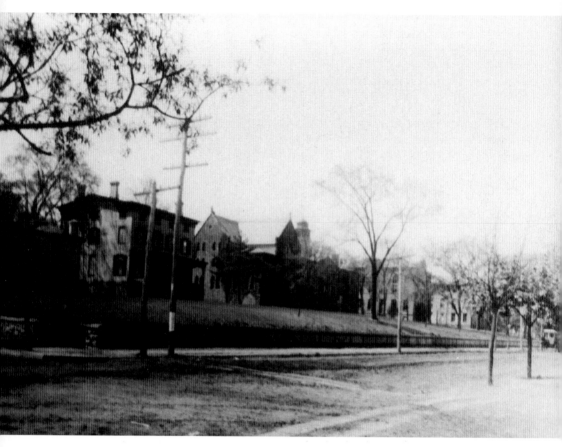

Above: Queens Campus, 1890. Looking north on George Street, this rare photograph shows the president's house, built in 1841. Also shown is the Kirkpatrick Chapel and Old Queens. The president's house was later used as the fine arts building, and was eventually demolished to make room for a parking lot.

Opposite below: Ballantine Gymnasium, 1893. The famed brewer of Ballantine Beer, Robert Ballantine, presented this structure as a gift to his alma mater in 1893. The gymnasium contained a drill room for the Rutgers Cadet Corps, a gymnasium, a running track, a ball cage, a bowling alley, a swimming tank, and locker rooms. In 1913 Mrs. Ballantine presented the money for the addition of a swimming pool. In 1930 the structure was destroyed by fire.

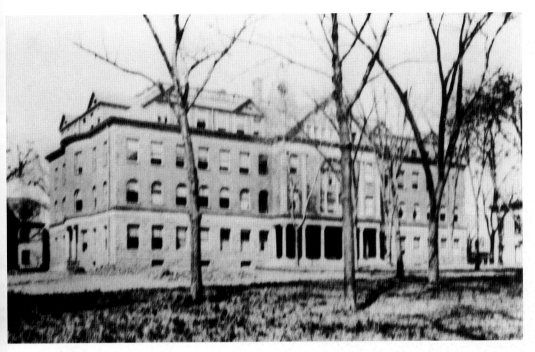

Above: Winants Hall, *c.* 1899. By the late 1880s enrollment had grown to the point that the college was forced to build a separate dormitory building. In 1890 Winants Hall was completed on the Queens campus, facing the campus green and overlooking College Avenue. The structure was of huge proportions and although it was a bit large for the campus, its graceful lines blended well with the older buildings. It is still used today by the college administration.

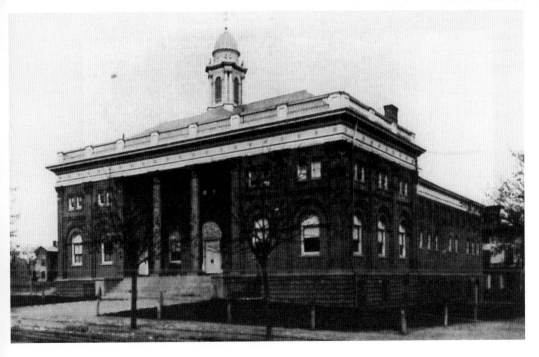

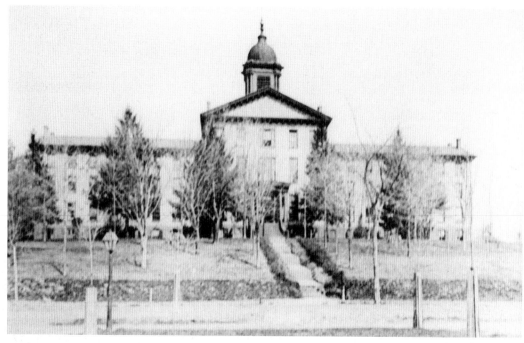

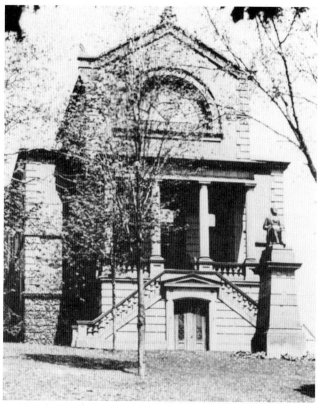

Above: Theological Seminary, 1856. The seminary of the Dutch Reformed Church is today the oldest such school in the country. Founded in 1784 by Professor John H. Livingston and originally housed in Queens College Hall, the seminary was given a lot north of the college grounds in 1856, where the Peter Hertzog Theological Seminary was constructed. The edifice housed the lecture rooms, library, dining hall, dormitories, and chapel. Hertzog Hall was demolished in the mid–1960s and replaced with a modern seminary building.

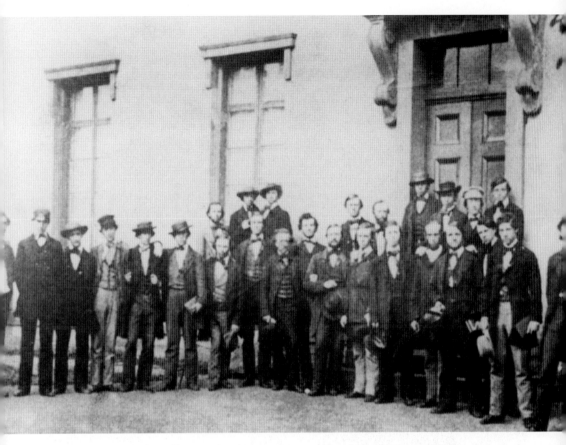

Class of 1859. Although small composite photographs were taken from 1856 until 1859, this photograph, taken in front of Van Nest Hall in 1859, is the earliest known portrait of a Rutgers class. The faces of these graduates certainly appear more like nineteenth-century businessmen than college students.

Opposite below: James Suydam Hall, 1871. Designed by Dietlief Lienau, this Basillican-style structure was located opposite Suydam Hall on the corner of George Street and Seminary Place. The building served as both the gymnasium and the chapel. It was destroyed sometime after 1950 and today only the statue that once stood at the entrance remains.

RUTGERS COLLEGE

GRAMMAR SCHOOL,

WILL BEGIN ITS 104th YEAR, ON

MONDAY, SEPTEMBER 1st, 1873.

☞ For Particulars, Circulars, Etc., apply to

D. T. REILEY, Rector.

Rutgers Preparatory School. Rutgers Preparatory—or Rutgers Prep as it is better known—was formed in 1766 in New Brunswick by John Leydt, J.R. Hardenbergh, J. Van Harlingen, A. Beach, John Cochran, and W. Oukes. The school was formed as a place for higher grammatical studies and was attended by the city's most affluent persons. The original location of the school was on Hamilton Street at Easton Avenue. Around 1850 the Ol' Trap on the corner of College Avenue and Somerset Street was purchased. In 1963 this school was vacated, and students moved to the Elm Farm Campus in Franklin Township.

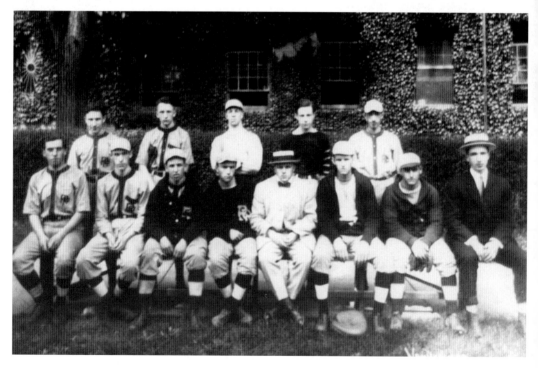

three

Our Volunteers

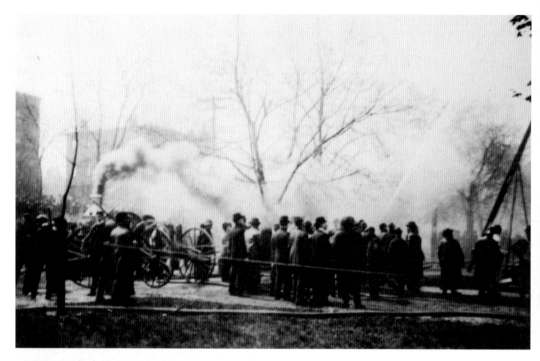

Above: New Jersey Hall fire, 1908.

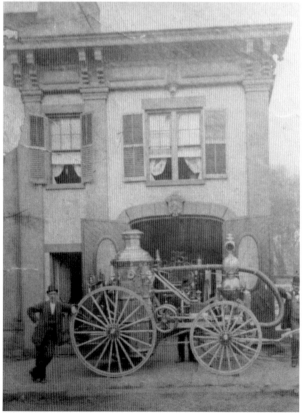

Left: Washington Engine Company No. 1. As a salute to President George Washington, New Brunswick's first organized fire company was named after him on October 11, 1795. During the first ten years of this company's existence, the members had no engine, only buckets and axes that were kept at the first engine house on Burnet Street. The company, whose members included many of the city's aristocrats, received a new hand engine around 1820 that was later destroyed at the great city dock fire. Washington Engine moved into its third house next door to Andrew Agnew on Burnet Street in 1859. This unique engine house was home to the city's first steam fire engine, a Button that remained in use until 1902. The Washington Engine Company was also the first company in New Brunswick to have horses to draw the engine.

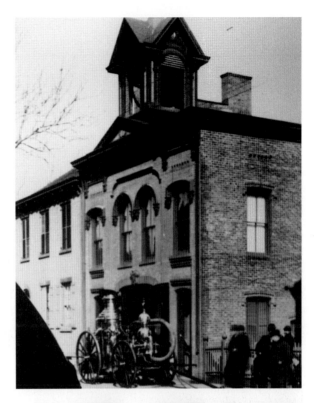

Washington Engine Company, 1899. Between 1859 and 1879 the old engine house was torn down and rebuilt in a more ornate style, and at this time a tower was also added for an alarm bell. This structure remained a firehouse until 1914, when the volunteers were disbanded, ending Washington's 119 years of service. The building remained standing until 1951–52 when it was demolished for the construction of Route 18.

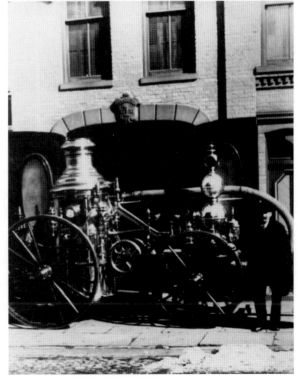

Washington's Button Steamer, 1899. A close-up view of the 1867 Button reveals the intricacy of this engine. Capable of pumping nearly 1,000 gallons per minute, it could throw a stream of water over the tallest church steeple in town. The Washes are shown here posing with their pride and joy, which won top awards at the 1871 Waverly Fair. Note the ornate keystone over the engine doors, and the hand-carved engine room doors.

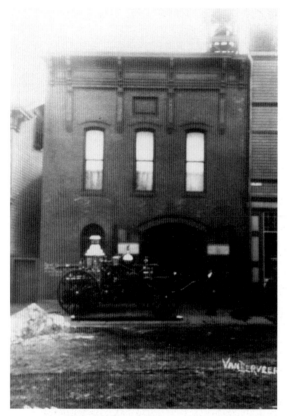

Left: Neptune Engine Company No. 2, 1899. Late 1795 saw the organization of New Brunswick's second fire company. The Christ Church donated land for the erection of the first engine house in 1800. Known as the "Red Jackets," this volunteer corps moved into the new city hall on New Street in 1857, where they shared quarters with Phoenix Engine Company No. 3. The company then moved to New Street, above Codwise (Joyce Kilmer Avenue), where they built this building, which remained their home until 1914, when it was taken over by the paid fire department.

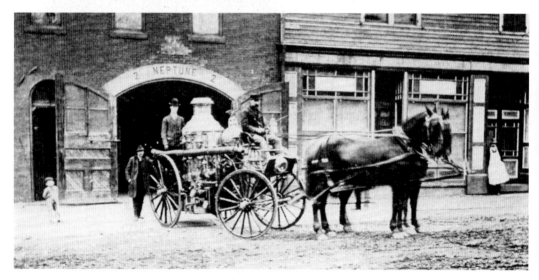

Neptune's Lafrance, 1903. Fire horses were some of the best friends firemen had. Horses were first used in this capacity in the 1840s in New York City. They gained acceptance only slowly, since many old-timers refused to let an animal perform what they regarded as their job: pulling the engine. In 1900, Chief John D. Pierce of the Neptune Engine became the first fire chief to die in office when he succumbed to an illness on July 25.

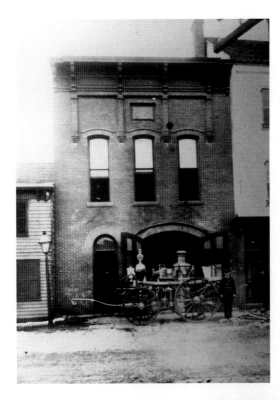

Left: Phoenix Engine Company No. 3, 1899. New Brunswick grew rapidly at the close of the nineteenth century, and fire protection became very important. In 1798, Phoenix Engine Company No. 3 was organized on Little Burnet Street. Local citizens financed the purchase of three hand engines and a steam engine. On March 31, 1866, the Amoskeag Locomotive Works of Manchester, NH, delivered this third-size steam engine to the Phoenix boys. Although the company disbanded in 1914, the building stood until about 1978.

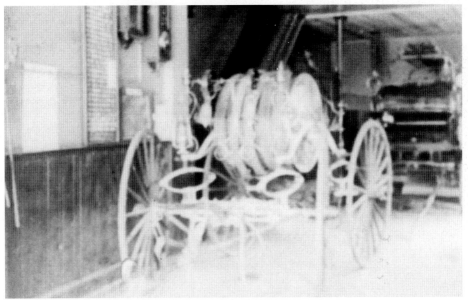

Interior of the Liberty Hose House, 1898. Interior views of nineteenth-century fire stations were seldom taken, making this one especially unique. Sitting in the wood-paneled hose house is the old four-wheeled hose carriage (purchased in 1867), along with the new 1895 hose wagon to the rear. Note the old fire alarm location box and the brass pole to the rear near the stairs.

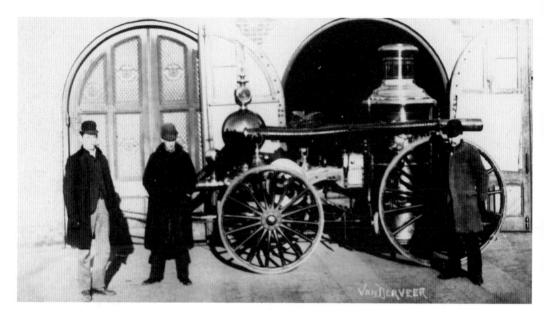

Raritan Engine Company No. 4, 1899. Originally formed as a hook and ladder company in 1795, this group became the fourth engine company in 1803. The first firehouse was built on the corner of George and Schureman Streets, and the group later occupied the center bay of the old fire headquarters built in 1868 on George and Schureman Streets. In 1886 the company moved to a new house on the corner of Remsen Avenue and Suydam Street.

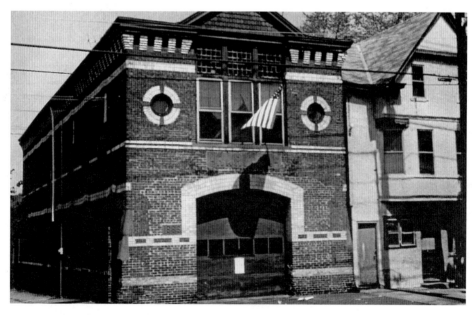

Raritan Engine House, *c.* 1978. New Brunswick instituted a part-time paid fire department in March 1912. By 1914, the paid fire department displaced the volunteers completely. Raritan's 1905 LaFrance steamer was then attached to a C.J. Cross motor tractor, and it served the paid department until 1918. Standing today on the corner of Remsen and Suydam Avenues, the firehouse in this photograph (since altered) stands as a proud reminder of the fine fire laddies.

Left: New Brunswick Hook and Ladder Company No. 1, 1899. Built in 1868 to replace an earlier frame structure, this building stood until about 1930. One company that called this station home was the New Brunswick Hook and Ladder Company, which was organized in 1835. In 1867, the company purchased this fine hand-drawn ladder truck that was kept as a reserve truck in the twentieth century. Note the four hand lanterns and the canvas fire coats folded along the top railing.

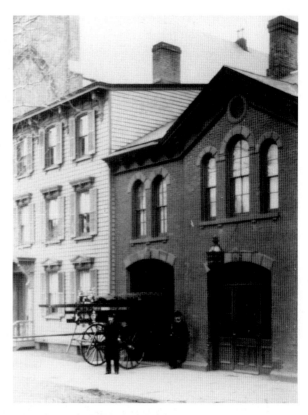

Below: An 1896 ladder truck. Used until 1914, this ladder truck replaced the 1867 one. It was designed to be pulled by horses and boasted a tillerman's seat (for the truckman who steered the rear) and enough room for nearly all forty members. Among the members of this company were Otto O. Stillman, city jeweler and optician, who served as foreman of the company in 1893.

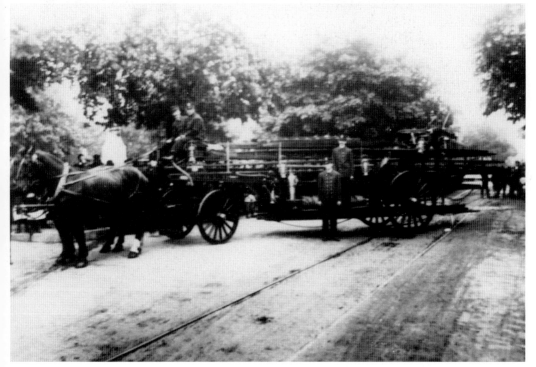

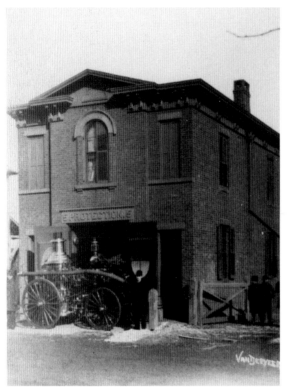

Left: Protection Engine Company No. 5, 1899. Photographer I.S. Vanderveer captured the members of the Protection Engine Company at their old house on George Street. The company, first formed in 1817, constructed this house to shelter their old hand engine in 1843. In 1868 the company bought a Haupt steam engine, which was later replaced by a Silsby in 1885. In 1904 the Pennsylvania Railroad purchased the firehouse to construct a new freight right-of-way. The old house was then razed.

Below: Protection Engine House, 1995. Protection Engine Company built their third house on Wall Street in 1905. In 1914, the house was closed by the paid department. The sign above the old apparatus doors, carved in 1842 and long since bricked over, reads **"5 PROTECTION 5."**

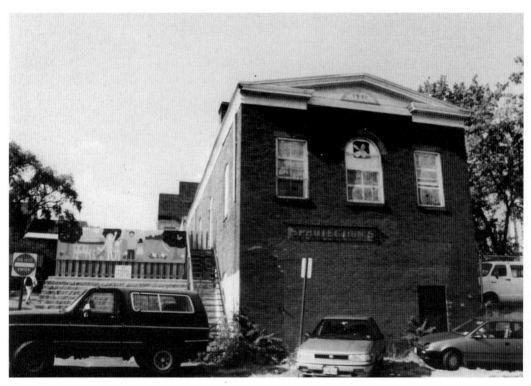

Right: Liberty Hose Company No. 1, 1899. Three policemen and two company members are shown here posing proudly with the 1867 "Spider" hose carriage. Liberty Hose Company was formed on July 31, 1853, by resolution of the common council. In 1868 the company took up residence in the fire headquarters on George Street. In later years the company held many fairs and fish dinners to supplement the small income from the city council in order to keep the company strong.

Below: Liberty Hose, 1902. This company was the only one to have two members killed in the line of duty. James Fisher and John Thomas were both killed in an unknown fire in the 1870s. In 1902 this fine new chemical, hose, and ladder truck was placed in service. This vehicle had the distinction of being the last purchased by the volunteers. On July 1, 1914, Liberty Hose Company No. 1 became Engine Company 7 of the paid department.

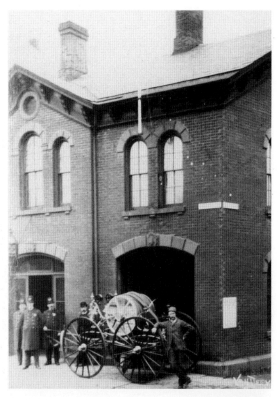

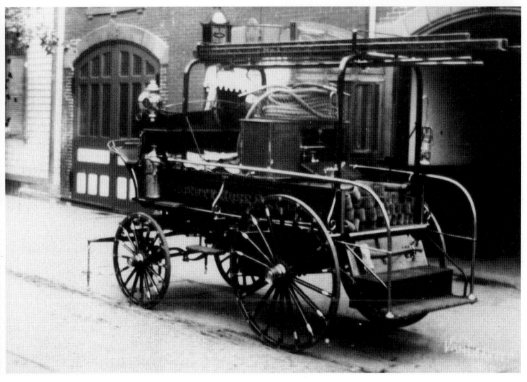

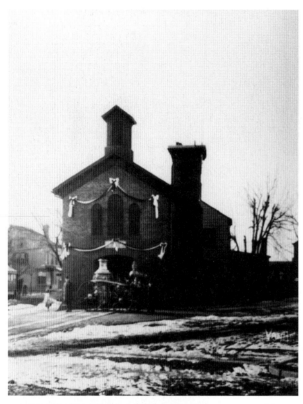

Left: Hibernia Engine Company No. 6, 1899. "To assist the suffering and protect the weak" was the mission of Hibernia Engine No. 6 of the sixth ward. After being housed in a Guilden Street barn, the company built a large, brick engine house on the southwest triangle of Easton Avenue and Stone Street. In the tower hung the old bell of Hibernia Engine Company No. 5 of Elizabeth, New Jersey, which was given to New Brunswick in 1902.

Below: Hibernia Engine, 1899. The pride of the Hibernia Company was their 1871 Dennison steam engine. This engine was as functional as it was beautiful, and remained in service for thirty-three years. During these years the engine fought every major fire in the city, including the Camden and Amboy Railroad Bridge fire in 1878 (see p. 111) and the Masonic Hall fire in 1896.

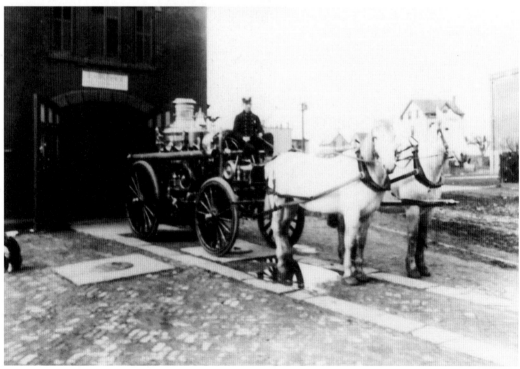

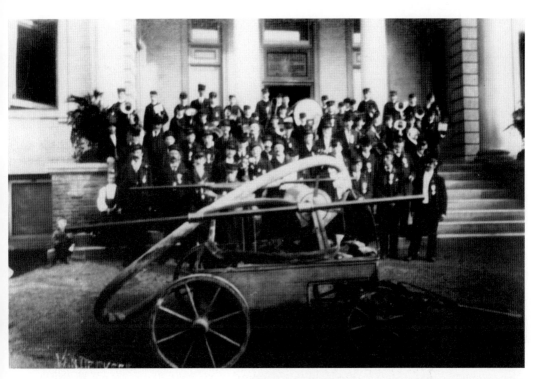

Above: Exempt firemen, 1905. Photographed on the steps of the public library are the members of the Exempt Firemen's Association. Organized in May 1905, this group was open to all men who spent seven years as active firefighters in any of the city's eight volunteer fire companies. Henry Housell was elected as the first president. Shown in the foreground is an ancient side stroke pumper *c. 1800,* which was most likely used by the Washington Engine Company No. 1.

Right: Fireman's Monument, 1914. Erected in 1914 in honor of both the active volunteers and the exempts, this monument originally stood on the county courthouse grounds. After the new courthouse was built, the monument was disassembled and moved to a new location. Coincidentally, the monument was put up on the spot of the old Hibernia House on Easton Avenue (see preceding page).

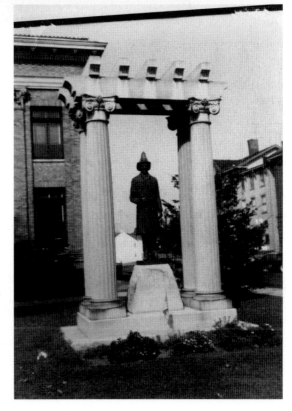

Paid Fire Headquarters, c. 1938. Steps were first taken toward forming a paid fire department on March 29, 1912. By 1913, Thomas J. Murphy became the first full-time paid fireman; he was captain of the Hook and Ladder Company. Finally on July 1, 1914, the volunteers were dissolved along with the part-paid department. A new fire headquarters was built c. 1920 on Joyce Kilmer Avenue. Today the New Brunswick Fire Department consists of five engines, two reserve engines, one ladder company, one reserve ladder company, and a rescue company, which respond from three stations.

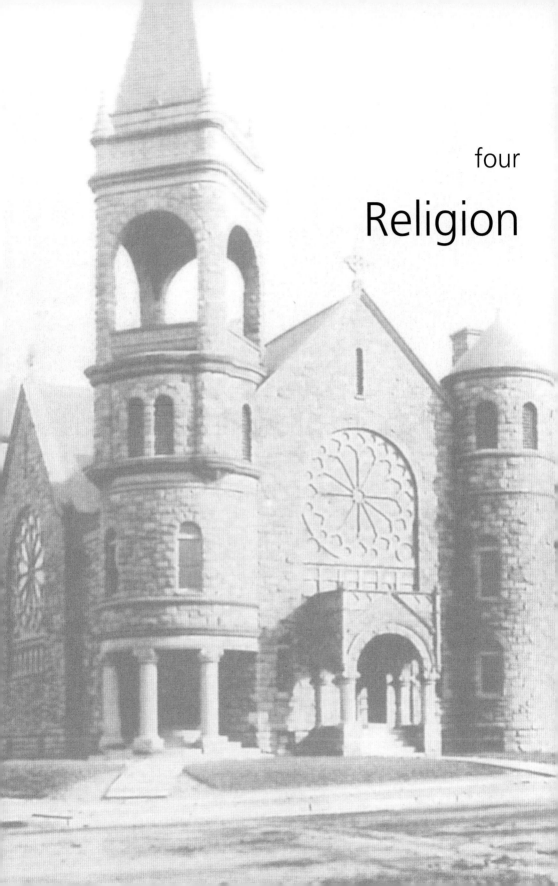

four

Religion

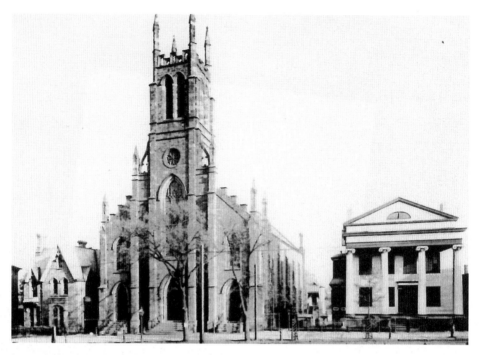

Above: Saint Peter's Roman Catholic Church, 1865. On Sunday, December 18, 1831, Father Schneller blessed the first Catholic church building, located on Bayard Street, directly across from the public school lot. In 1835, the old church was damaged by a tornado but remained standing until the present church was completed in 1865. The new church was built in the Gothic Revival fashion on Somerset Street. The rectory (on the right) pre-dates the church building; the convent was built *c.* 1870.

Opposite page:
Top left: First Reformed Church, *c.* 1860. The last service was held in the old church on May 20, 1811. At that time the structure was dismantled to make room for the present structure. Finally, one year, four months, and one week later, the dedication ceremony of the new church was conducted by Reverend Doctor Livingston. Located on Neilson Street mid-way between Paterson and Bayard Streets, the First Reformed Church is today the oldest in the city.
Top right: First Reformed Church, *c.* 1860. This house of worship is a fine example of the Neoclassical style, which was popular from 1790 until about 1825. Architecturally speaking, the First Reformed Church follows the plan nearly perfectly: it is three bays (openings) wide and five bays deep. It seats eleven hundred parishioners, and was slightly remodeled in 1847 and in 1862. Unlike most other structures of its time, the church remained and did not sell out to developers.
Bottom left: Christ Episcopal Church. In 1745 Philip French presented a tract of land to the Church of England for the erection of a place of worship. The church was started in 1763. This edifice closely followed the lines of English parish churches, and contained "a noble window of small panes of glass" along the entire rear wall. By 1774 the tower and steeple were completed; for many years the steeple was the tallest man-made point within the city.
Bottom right: Christ Episcopal Church. By 1852 it was decided that the building needed to be enlarged. The entire structure was torn down, with the exception of the tower, and the church was rebuilt using the original stones. Several noteworthy church members are buried in the graveyard: Bishop John Cross (died July 30, 1832); Mr. Beach (who presided over the church during the Revolution, and died in 1828); and Reverend Alfred Stubbs (who was laid to rest on December 12, 1882).

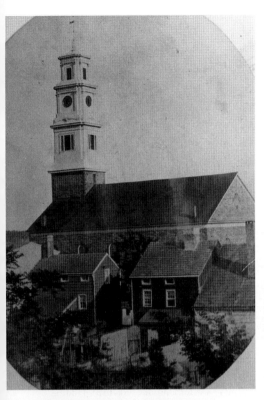

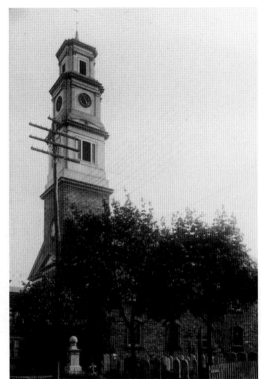

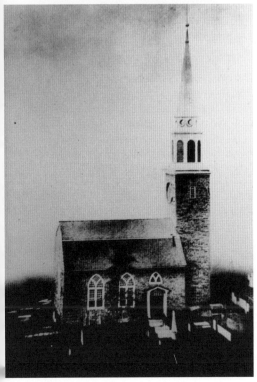

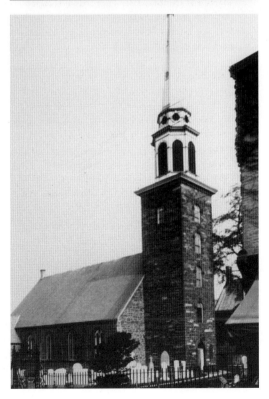

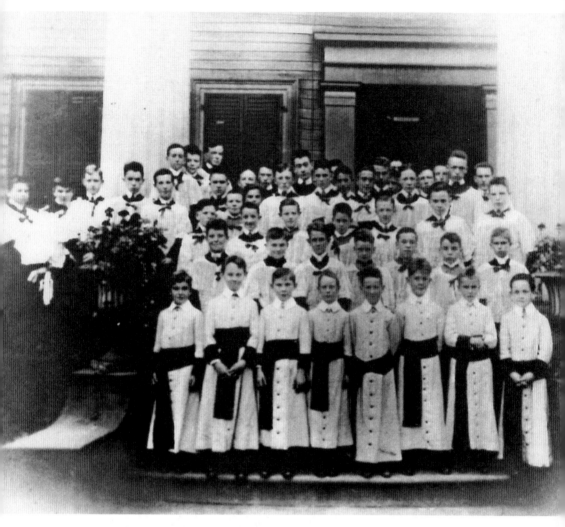

Saint Peter's altar boys, *c.* 1922. Many of the city's young, upstanding citizens were honored in the Catholic church when they were allowed to become altar boys. To the extreme left of the photograph is Pastor John W. Norris. Pastor Norris served at Saint Peter's from March 23, 1919, until he was appointed a monsignor in 1920 by the Trenton Diocese. Monsignor Norris passed away on May 8, 1928.

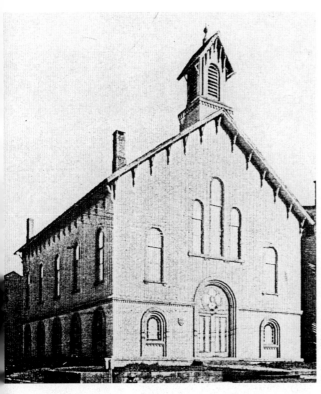

Pitman M.E. Church, 1852–1909. During a revival of Methodism in 1851, Reverend James D. Blain (pastor of the New Brunswick Methodist Church) advocated the establishment of a new church. The new parish quickly gained members and a lot was purchased on the corner of George and Oliver Streets. Soon, a new frame structure rose and was dedicated by Bishop Edmond S. Jaynes on August 11, 1852. In April 1909, the structure in the bottom photograph was completed on the site of the original church. The church was named in honor of Reverend Charles Pitman, who became the first pastor of the Methodist church in 1820. This edifice was completely destroyed by fire in 1994.

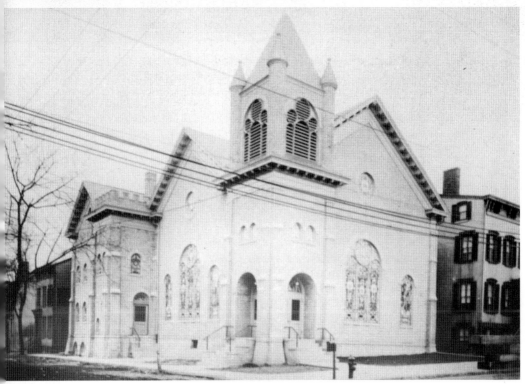

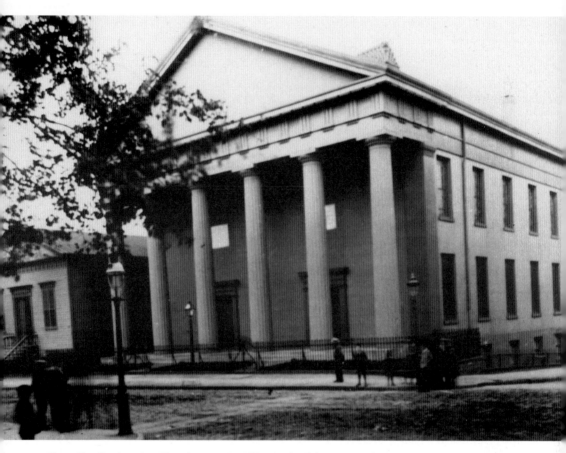

Above: First Presbyterian Church, *c.* 1880. Old records of the First Presbyterian Church were destroyed in the Revolution, but research traces the origins of this congregation to about 1726. The first church stood on Paterson Street and was known as the "Old Yellow Church" because of its brightly colored brickwork. Worship continued here until 1836, when Reverend Joseph H. Jones set about constructing a new church on George Street, at the corner of Paterson. This structure exemplifies the Greek Revival style that dominated American building design throughout the first half of the nineteenth century. A cemetery sat directly behind the church from about 1837 until it was removed in 1922. In place of the cemetery a school and community center were soon erected on the back of the church. This historic structure, which was nearly destroyed by fire in 1888, finally succumbed to the red devil in 1947.

Opposite above: Ebenezer Baptist Church, *c.* 1975. A small number of African-American citizens formed the Ebenezer Baptist Church in 1875. It is today regarded as the third oldest Baptist church society in New Jersey. The first house of worship was erected on Hale Street in 1876. The simple frame structure was vacated in 1922 when the congregation relocated to a fine new masonry structure. This new house of worship was completed under the direction of the Reverend Charles C. Weathers.

Opposite below: Wray Memorial Chapel, *c.* 1816. This ancient church house stood on lower Burnet Street past the steamboat wharf. Little information exists on the church's history. It does appear on a 1876 map, labeled only as "church" with no owner noted. The structure is, however, a fine example of a rural nineteenth-century church. Here, the doors to the vestibule hang open, almost in an attempt to draw parishioners into the church's lonely walls.

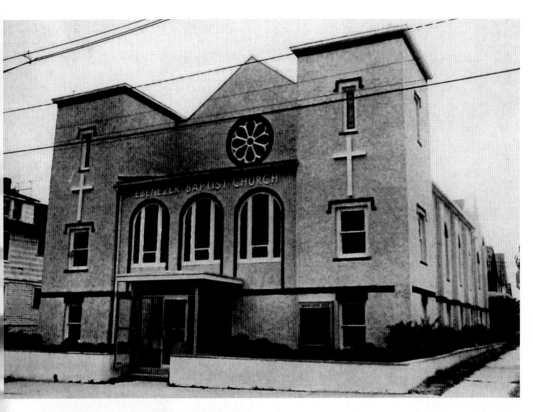

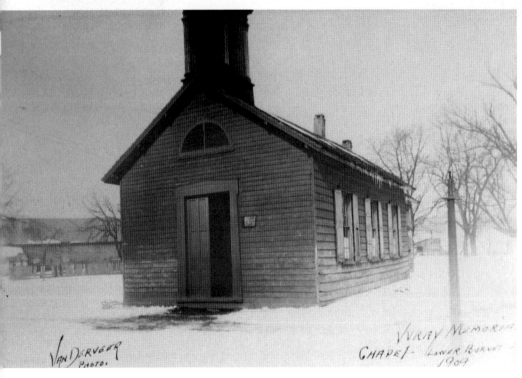

Van Derveer
Photo.

Wray Memorial
Chapel - Lower Burnt
1904

65

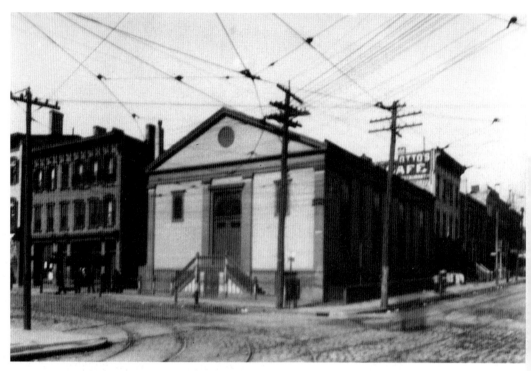

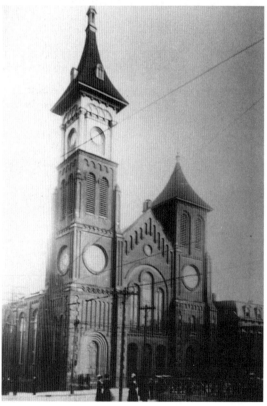

Above: Second Reformed Church, *c.* 1880. By the time this photograph was taken, the old house of the Second Reformed Church—built by the New Brunswick Amusement Company in 1840—had been sold to the German Reformed Church. For eighteen years the Second Reformed Church met here until a new church was built in 1861 on the opposite corner of George and Albany Streets. It was remodeled around 1911 into the Strand Theater (see p. 116), which remained standing until about 1970.

Left: Second Reformed Church, *c.* 1890. The new church was completed between 1857 and 1861 on the corner of George and Albany Streets. The church was built on land that was originally the site of a small brook fed by the old Barrack Spring. This edifice had several features of the Romanesque Revival style: heavy arched window and door openings as well as massive towers. The building was razed in 1925, only sixty-five years after its construction.

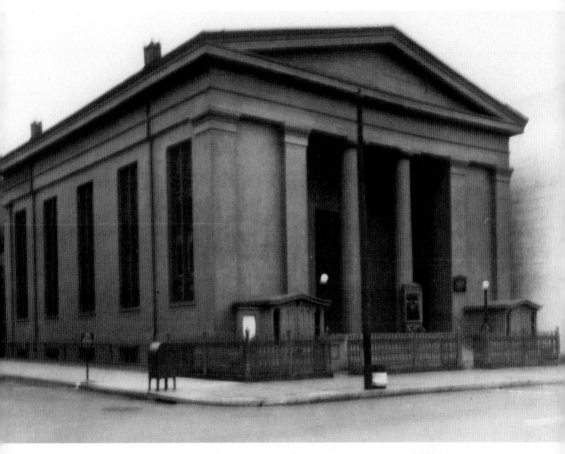

First Baptist Church, *c.* 1900. This church building was located almost directly across from the First Presbyterian Church on George Street. Completed between 1836 and 1838, the edifice replaced the first church, which had been purchased by the Camden and Amboy Railroad and demolished (see p. 110). The city's second Greek Revival church cost $15,459.30 (not including the furniture of course). From this original congregation, other Baptist churches were formed on Livingston Avenue, Georges Road, South River, and Highland Park. Like the others of the same era, this historic church was eventually demolished.

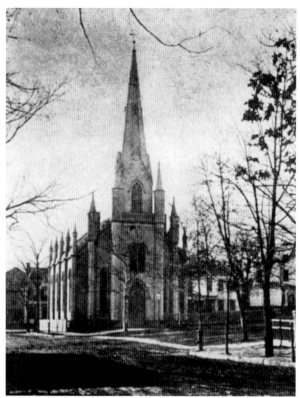

Left: Second Presbyterian Church, *c.* 1876. The triangular plot that is now the site of the Soldiers Monument, was once occupied by a church edifice. Bounded by George, Livingston, and Schureman Streets, this wood frame church was completed about 1845. This style of church was most commonly finished in brick; this particular structure was surely finished in wood because of budget constraints. In 1876 the church was razed and the site remained vacant until the early twentieth century.

Below: Old Methodist burying ground, *c.* 1930. Time seems to have forgotten the souls of the old cemetery in this view. The first bodies were laid to rest at this plot of ground on the corner of Oliver and Neilson Streets in the 1830s. Once ensconced by a fine wooden fence, the lot is today vacant and it is unknown if some of New Brunswick's finest town elders still remain resting below.

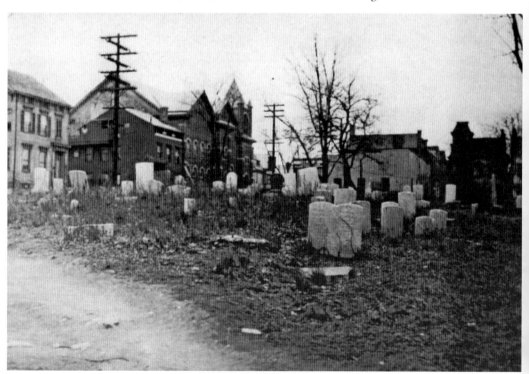

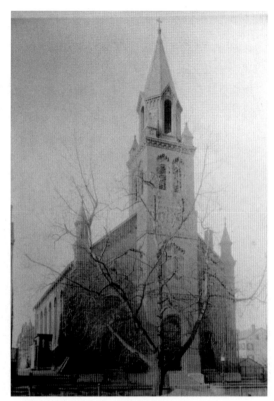

Right: Saint John the Baptist Roman Catholic Church, *c.* 1900. Comprised mostly of German-Catholic immigrants, this congregation was organized on November 8, 1865. Under the leadership of Pastor Gregory J. Misdziol, the parishioners purchased property on Neilson Street and began constructing this edifice the following year. The first marriage under this spire was performed by Pastor Misdziol on February 13, 1866, when Maria Grolling wed Martin Klein. Almost a century and half later, the church still stands on Neilson Street.

Below: Mount Zion Methodist Episcopal Parish. Among this group of parishioners is the Reverend Sturgis (far left); next to him is Thomas Marsh. The Mount Zion Methodist Episcopal Church was begun in 1827. It was the first African-American church established in the city. The first church house was on Division Street.

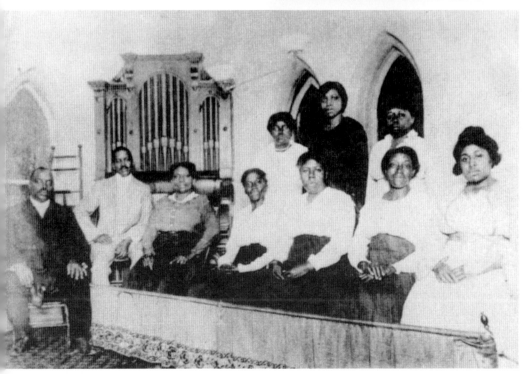

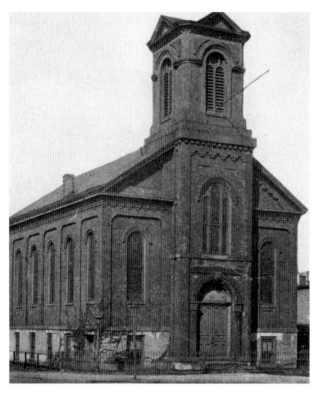

Livingston Avenue Baptist Church. Formed as an outgrowth of the First Baptist Church on George Street, this congregation began searching for a site to erect a church in May 1872. Under the direction of Reverend A.E. Waffle, a site was selected on Remsen Avenue near Redmond Street. The new church was dedicated in 1873, but by 1890 the congregation had grown considerably and it was time to move again. The old church became the Masonic Hall, and a new $49,500 edifice was built at the corner of Livingston Avenue and Welton Street. The building was dedicated officially as the Livingston Avenue Baptist Church, which it remains to this day.

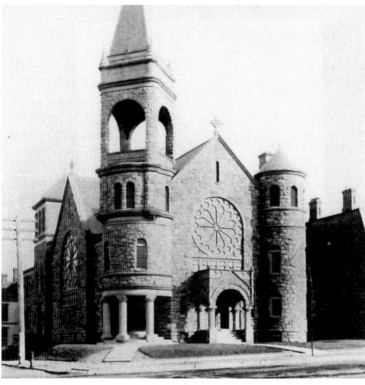

Home Sweet Home

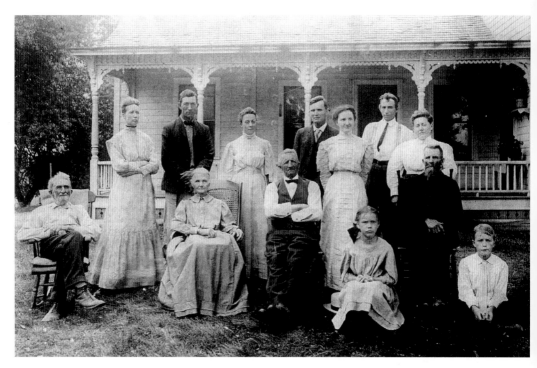

Unknown family portrait, c. 1899.

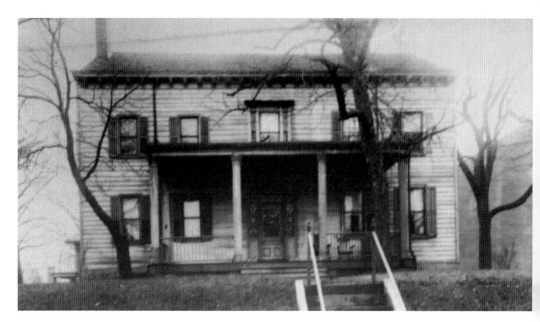

Livingston House, 1810. Now the site of the Livingston Avenue Apartments, this location was once the area where the Livingston House stood. The house was there until c. 1935. Built by John Henry Livingston in 1810, this structure was located in what was considered a rural area. The intricate doorway with arched fanlight and center window on the second floor are both trademarks of Georgian farmhouses of the late eighteenth and early nineteenth centuries in America.

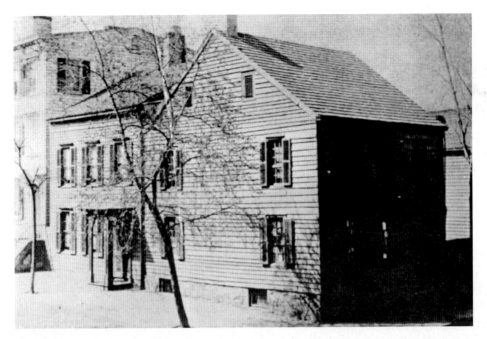

First library, c. 1790. Several early libraries in the city's history did not work out well, and by 1850 they had all become defunct. However, on March 23, 1883, the first free circulating library in New Jersey began in New Brunswick. The library purchased this old frame dwelling on the southeast corner of George Street in 1884. It served until about 1890, when the library relocated to Albany and Peace Streets.

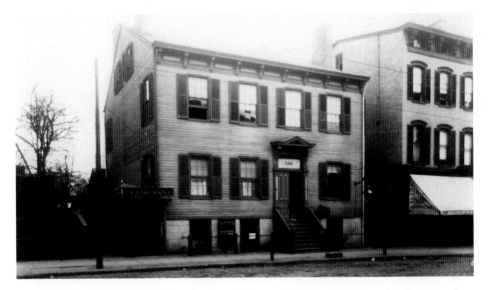

Scheidig's Restaurant, c. 1912. Now the site of Johnson & Johnson's corporate headquarters, the north side of Albany Street was once graced with this restaurant. Len Scheidig opened this restaurant in the basement of 135 Albany Street in 1890. Serving entrees from shrimp and thick steaks to clams and chicken, the establishment remained open until about 1929. The house itself dates back to c. 1820.

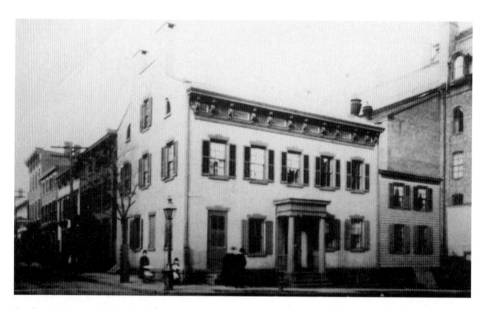

Spader House, *c*. 1812. One of the finest dwellings in the city stood on the northwest corner of George and Church Streets. Constructed by Mr. Peter Vanderbilt Spader, this imposing structure combined Greek Revival elements, such as the front porch, with more Georgian features, such as the chimneys incorporated into the gable end of the house. Mr. Spader himself became one of the city's first policemen when he and John Nafey were appointed in 1835. This edifice stood until about 1926 when it was removed and replaced with a commercial building.

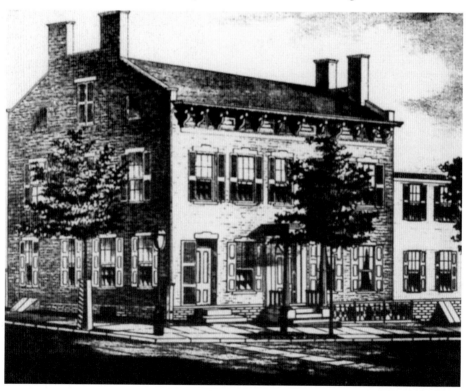

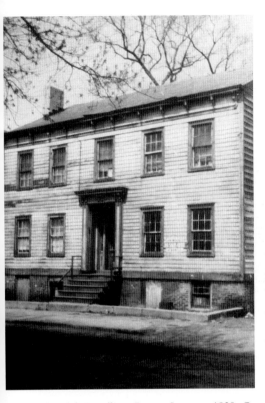

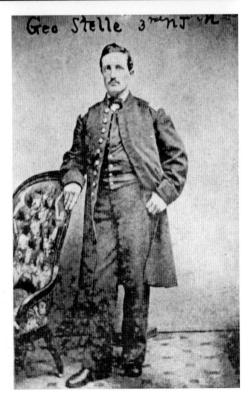

Above left: Dwelling, Burnet Street, *c.* 1829. One of the many structures that was razed in 1951 for Route 18 was this house. Long empty and forgotten, it was demolished soon after this photograph was taken. Note the unusual window pane arrangement.

Above right: Frame House, Burnet Street, *c.* 1800. The relentless destruction of lower New Brunswick becomes more profound when one observes the loss of an edifice such as the one shown here. Most of the historic structures in the city were demolished along with this fine Federal dwelling that stood on Burnet Street near Hiram.

Right: George Stelle, *c.* 1863. Mr. Stelle served as second lieutenant of the "National Rifles" during the Civil War. He joined the Union Army in Greer's Hall (see p. 26) in 1861. It is said that Mr. Stelle and his regiment left for combat on April 26, 1861, and stood as the first of the New Brunswick regiments to return from the war in 1865.

First Saint Peter's Hospital, *c.* 1875. Middlesex County's first hospital opened here in October 1872. Dr. Clifford T. Morrow was the supervisor of the institution until it closed only two years later in 1874. This ornate high Victorian structure with its mansard tower stood at the head of Easton Avenue and later became Saint Mary's Orphanage.

Russell Mansion, *c.* 1850. This edifice was located at the corner of Somerset and Hardenbergh Streets. Built by the Russell family in the pre–Civil War days, it was purchased by the newly organized Saint Peter's Hospital in 1908. During the 1920s, a new wing was added for maternity purposes that was vacated by the hospital in 1930. This structure featured a prominent front porch and a tower that included eight round arched windows. It was later razed.

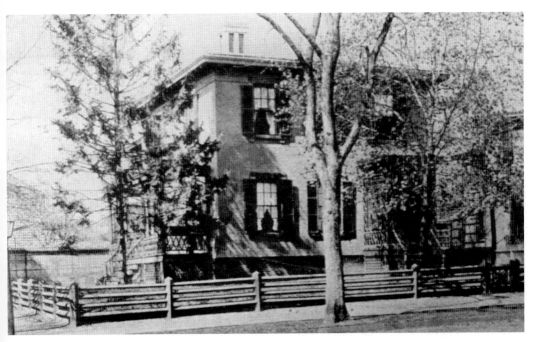

Kirkpatrick House, *c.* 1858. John Bayard Kirkpatrick finished construction of this fine brick dwelling house during his tenure as mayor from 1857 to 1858. Mr. Kirkpatrick worked for the U.S. Treasury Department in Washington from 1820 to 1850 and died in this house on February 23, 1864. His family occupied this dwelling well into the twentieth century.

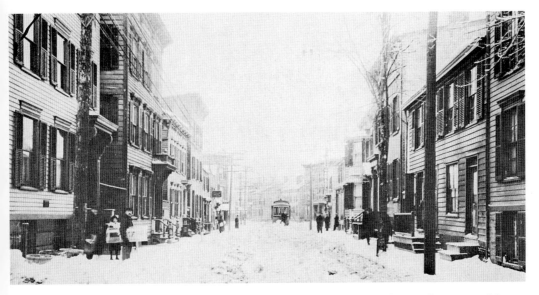

George Street, *c.* 1905. At one time George Street was the prime location for two things—wood frame houses and churches. George Street was originally laid out from Albany to Livingston Streets before 1800. It was later extended north toward the Queens campus and south when Schureman Street was opened.

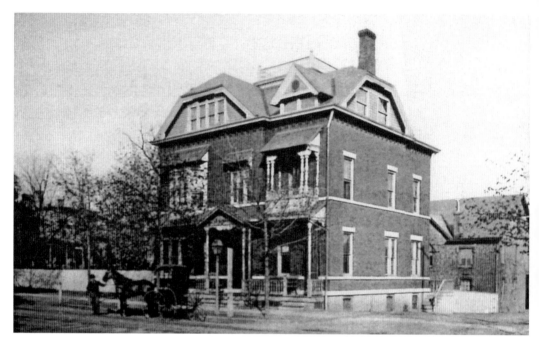

Dr. Slack's residence, c. 1886. Dr. Slack opened his general practice around 1895 at 48 Livingston Avenue. This house was unique in New Brunswick because few Queen Anne-style homes were built here. The building to the rear served as the doctor's carriage house. Although greatly changed, both of the structures are still standing today.

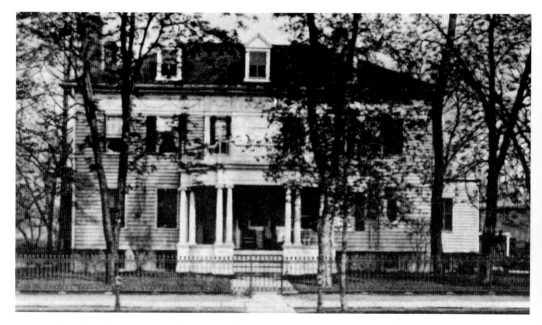

Professor Hart's residence, c. 1890. Also located on Livingston Avenue (at number 33) was this interesting Federal-style house. Occupied by Rutgers College professor Charles E. Hart, this structure was one of the many great homes that once graced the city's finest thoroughfare.

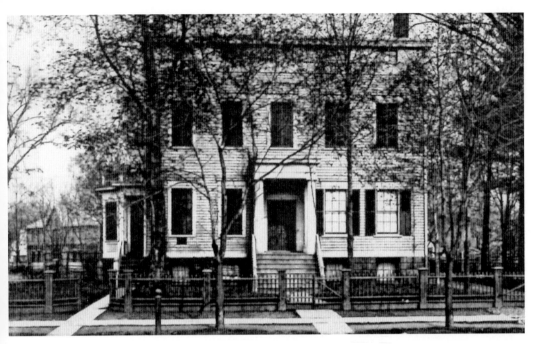

Applegate House, *c.* 1865. Constructed before the Civil War, this fine Greek Revival home once stood at 25 Livingston Avenue. The ornate frame house was in later years occupied by Dr. George T. Applegate. He maintained residence here, and the entrance to his office was most likely located where the steps appear on the right of this photograph.

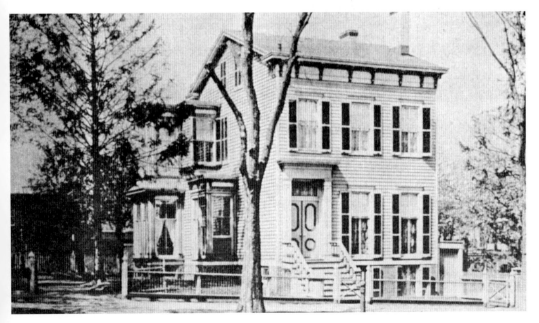

James Langdon House, *c.* 1875. This is a good representation of the typical New Brunswick house of the nineteenth century. Hundreds of wood frame houses were constructed according to this plan, three windows wide with offset entrance ways. The Langdon House stood on 24 College Avenue.

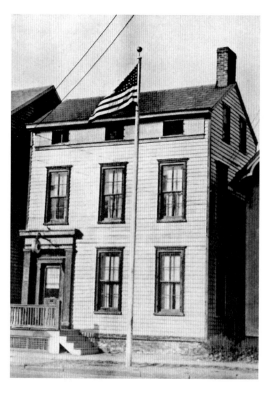

Joyce Kilmer birthplace, c. 1840. Joyce Kilmer was born in this modest wood frame Federal house at 17 Codwise Avenue (now Joyce Kilmer Avenue). In 1929, the house was purchased by the Joyce Kilmer Post of the American Legion and in 1969 it was purchased by the State of New Jersey.

Frances Joyce Kilmer. New Jersey's best-known poet was born in the upstairs bedroom of 17 Codwise Avenue on December 6, 1886. His father was a founder of the Johnson & Johnson corporation. Joyce attended Rutgers Prep from 1894 until 1904, and during that time he met his future wife, Aline Murray. Kilmer went on to graduate from Columbia University in 1908. When the World War erupted in 1916, Joyce Kilmer enlisted and in 1918 was killed on duty in France.

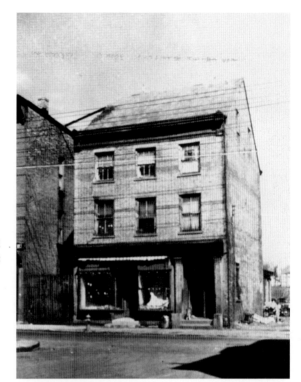

Burnet Street house, *c.* 1820. Like many other Dutch ancestral homes, this one had a brick front with wood frame sides. Most families could only afford to decorate the front of their homes in this style. This feature made the home appear elaborate from the street, and gave the appearance of a substantial brick house. By 1951, this old house was converted to a store and was soon visited by the wrecking crew that worked its way down Burnet Street.

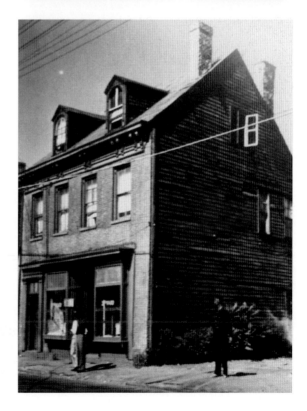

Burnet Street house, *c.* 1820. This brick structure was removed in 1951–52. Today, the photographs of these vacant and ill-repaired relics are the only reminders of lower New Brunswick and its early history.

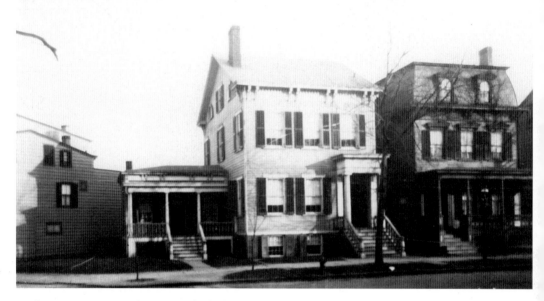

Dudley House, c. 1860. The corner of Schureman Street and Livingston Avenue was once home to these edifices. The Dudley House was built around 1860 in the Greek Revival style, while the mansard-roofed house to the right was completed c. 1872. The two houses, although very different, complemented each other to the fullest, thanks to "the carpenter's magic."

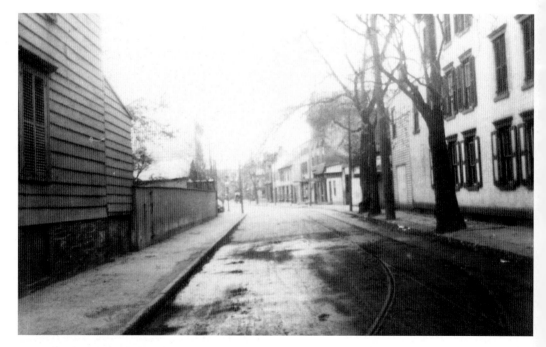

Deserted street. Such lonely photographs were seldom taken during the early years of photography. Here, looking down Neilson Street, it seems that everyone has left the city to Mr. Vanderveer and his camera.

six

Business and Industry

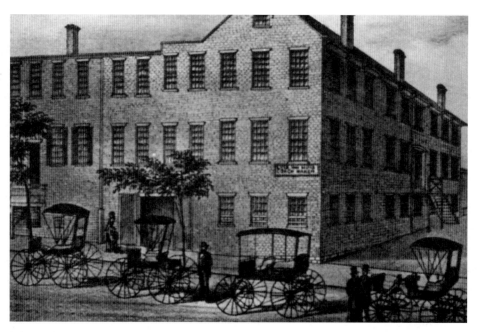

New Brunswick Carriage Factory, *c.* 1813. Lyle Van Nuis (mayor 1856–57, 1861–63, and 1877–79) was the proprietor of this city carriage company. Mr. Van Nuis was born in 1813 and inherited the company from his father, who started it in 1811. In 1839 the building pictured was erected on Washington Street. The Neilson family purchased a Van Nuis carriage in 1839 and it was still in excellent condition in 1890, a true compliment to the factory's work.

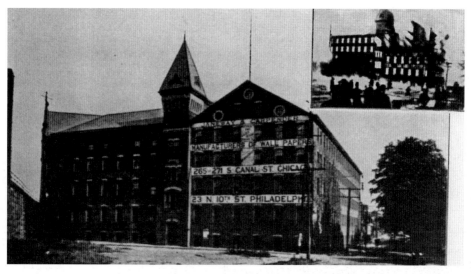

Janeway and Carpender, *c.* 1880. The Janeway and Carpender Company was started in a small factory on Water Street in 1849 by William Janeway. In 1879, the immense factory pictured here was built on the corner of Paterson and Schuyler Streets. They manufactured all types of wallpaper at this location. In 1907, this building was completely destroyed by fire (see inset). The company then moved to a new building in Highland Park after nearly sixty years in New Brunswick.

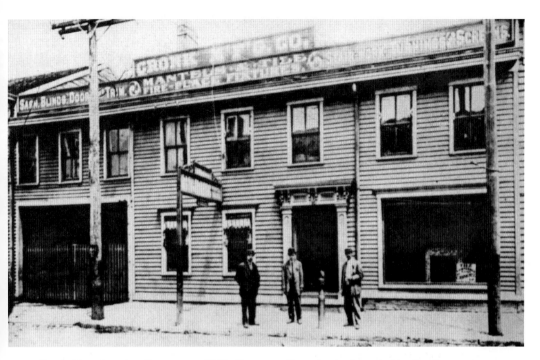

Cronk Manufacturing Company, *c.* 1888. One way of securing business during the nineteenth century was to dabble in everything. The Cronk Company did just that while they were located at 139 Burnet Street, selling wooden boxes, moldings, doors, tile, stairs, and even cast-iron fireplace fixtures. If all of that wasn't enough to keep them busy, the Cronk Company took to the streets, offering home delivery of everything they made.

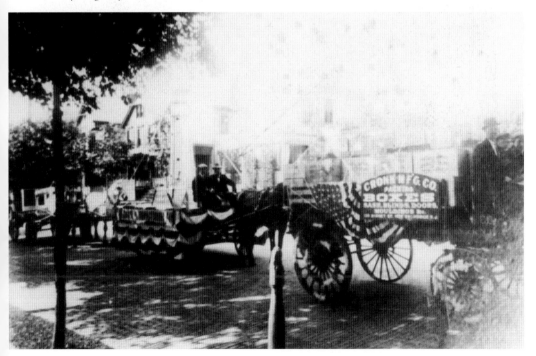

Dunham House, *c.* 1799. Around 1825 Charles Dunham purchased this ancient dwelling on Burnet Street almost adjacent to the Agnew house (see p. 31). The first floor of the building was soon converted into a store, and a residence was located on the second floor. Vacant for nearly thirty years when this photograph was taken, it was soon removed for the construction of Route 18.

Stillman jewelry store, *c.* 1890. Mr. Otto Stillman opened his jewelry and optical store in this brick structure sometime in the late 1890s. Located at 138 Albany Street next door to Scheidig's Restaurant (see p. 75), this building was built about 1868. It remained standing until the 1970s when it was removed for the construction of Johnson & Johnson's world headquarters.

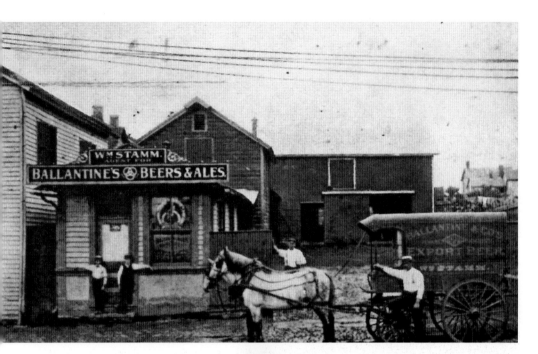

Above: Stamm's Beer Company, *c.* 1900. William Stamm operated one of the few beer companies in New Brunswick and Middlesex County at 161 Throop Avenue. Stamm's dealt with both imported brands, such as Ballantine and Smith's Cream Ale and Porter, and domestic brands, such as Anheiser Bush and Schlitz. Mr. Stamm, who was from New York City, was also a volunteer fireman with Protection Engine Company Number 5.

Right: Isaac Vanderveer Studio, *c.* 1899. As you enjoy the images in this book, take the time to appreciate the man who photographed many of them, Mr. I.S. Vanderveer.Mr. Vanderveer's love of history, combined with his photographic skill, made him especially suited to capturing New Brunswick's buildings, streets, and faces for years to come. Ironically, no image seems to be available of Vanderveer himself. The basement of this Gothic frame house was home to his studio for some time.

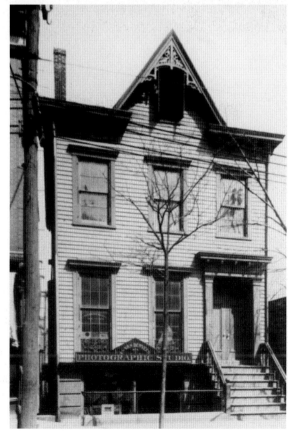

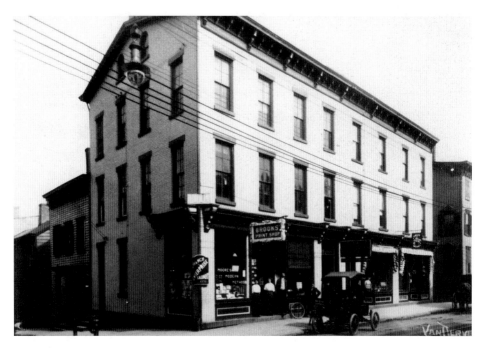

Weigel Building, 1909. After its construction during the Civil War, this building became the city's largest store. It stood on George Street at the corner of Paterson Street until the early 1970s. For many years, the principle tenants were Brook's Print Shop and The Singer Sewing Machine Outlet. Note the early electric-powered car.

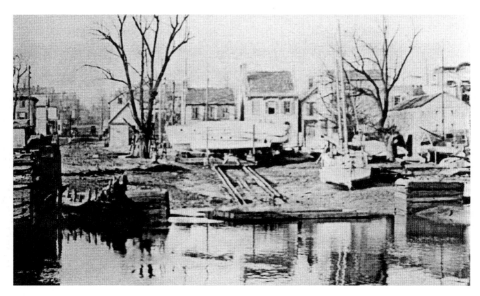

Kempton Shipyard, *c.* 1890. John Wesley Kempton launched his vessel, the *Sloop Grey Ground*, from his Burnet Street yard in 1804. For the next fifty-one years, all types of craft were turned out, including sloops, barges for the Delaware and Raritan Canal, and in later years, an occasional pleasure craft. Among some of the ships built here were the *Fox* in 1817, the *Somerset* in 1824, the *Whale* in 1835, and the *John Conover* in 1856.

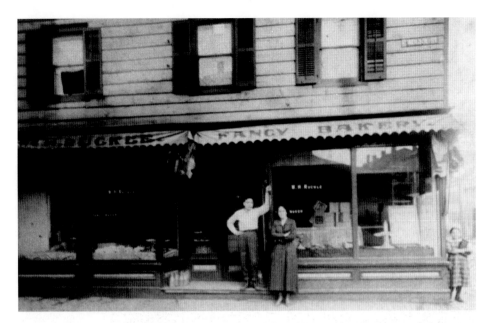

Ruckle's Bakery, c. 1910. By the turn of the century, there were no less than twenty bakeries in the city and William H. Ruckle owned one of the finest. Located on Neilson Street near Albany in an old frame building, the store was opened in 1898. All types of breads, fresh flour, and pastries could be purchased here. It was a daily ritual for many young lads to stop in for two-penny shortbread cookies on their way home from the Bayard School.

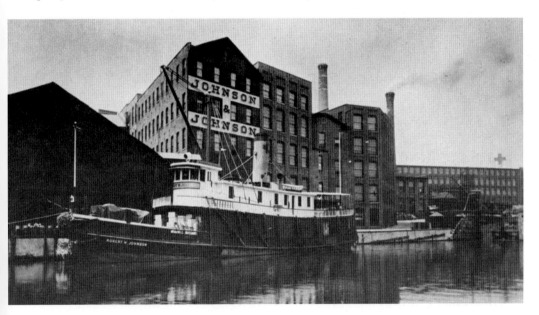

Johnson & Johnson, c. 1908. Johnson & Johnson began in a small factory near the depot in 1886. By 1891 they had moved into the Novelty Button Works. The company began selling surgical supplies such as dressings, cotton, and bandages. All of the early buildings were well-lit and ventilated, as cleanliness was important to the company. Today, Johnson & Johnson currently maintains its corporate headquarters in New Brunswick only a few hundred yards from where the company began in 1886.

William Reed blacksmith shop, *c.* 1890. Mr. Reed opened his blacksmith business in this old shop on Burnet Street in the 1850s. In the 1840s and '50s it was necessary to provide good service and friendly competition in the blacksmith trade in order to cultivate the loyalty of industrial and aristocratic customers along Burnet Street.

Hingher Furniture Company, *c.* 1890. Edward Hingher opened this furniture company at 116 Neilson Street on the corner of Schureman in 1880. Utilizing two buildings, he joined them together by quickly renovating the early-nineteenth-century structures for commercial use. Mr. Hingher carried a complete line of furniture but specialized in dining room tables and chairs, pine hope chests, and walnut handrails. The structure was demolished by 1940.

Howell lumber yard, 1890. Hundreds of structures in Middlesex County were built with lumber from the Howell yard. Located on Burnet Street against the banks of the canal, this yard occupied the former site of the Neilson house (see p. 16). It has been said that the mill building on the left was reconstructed with Neilson house bricks. The structure on the right served as the main lumber and drying shed. All buildings shown here were razed during the construction of Route 18.

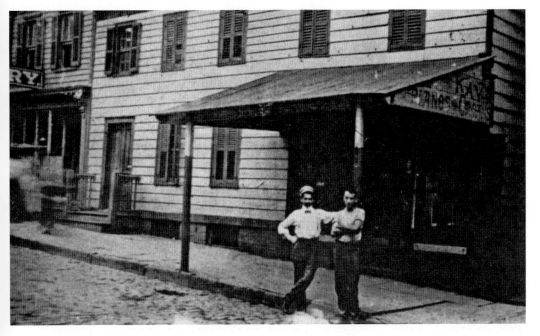

Kay's piano showroom, c. 1902. Many of New Brunswick's oldest frame houses were given a new lease on life as commercial buildings. This structure is thought to have stood on Albany Street near George Street. The two men, most likely salesmen, are standing quite still as opposed to those on the left who moved, causing a blur because of the very long shutter speed required in early photography.

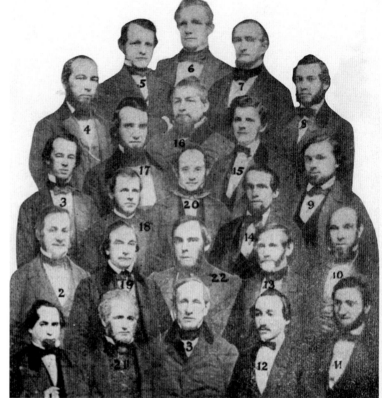

Right: City merchants, 1859. This interesting collage of New Brunswick's leading businessmen was compiled just before the Civil War. Those photographed include: Moses Levy, Ezekial Miller, J. Smith, Peter Stryker, Henry Towle, G. Voorhees, Dr. David English, W. Rowland, W. Stoddard, Van Buren Schenck, A. Wolfson, M. Segel, H. Richmond, Peter Brunson, A. Voorhees, W.M. Van Sickle, O.B. Gatson, W.H. Armstrong, I. Voorhees, Abe Wolfson, A. Jackson, G. Mettler, and D.H. Merritt. What a handsome group!

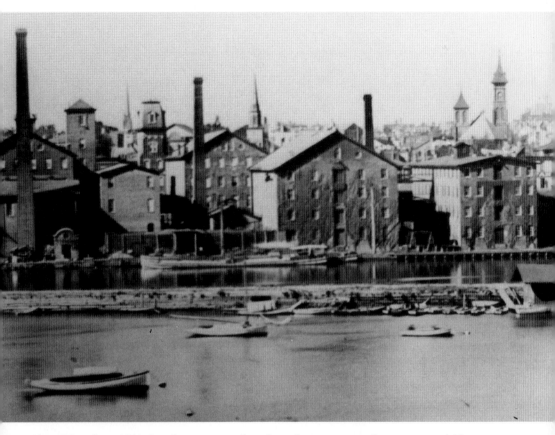

Above: Waterfront, 1890. Steeples, towers, and smokestacks rose to greet the newcomer to New Brunswick. Here, the entire waterfront is dominated by the factory buildings of the New Jersey Rubber Company. Over twelve structures and no less than three chimneys made up the complex. To the extreme right is the Raritan House, later the Hotel Klein (see p. 33). Also note the wooden cribbing filled with earth that created the artificial towpath between the river and the canal.

Opposite below: Paterson block, *c.* 1940. The Paterson Block still stood tall and solid one hundred years after its creation. Located on the corner of Burnet Street at the intersection of Little Burnet and Peace Streets, this building was part of Commerce Square (see p. 29). It was named in honor of Governor William Paterson (New Jersey's first governor), who kept his mansion on this spot overlooking the river. The house was demolished *c.* 1835, when the Paterson Block began to rise. The block stood until 1951, when it was removed during the construction of the infamous Route 18.

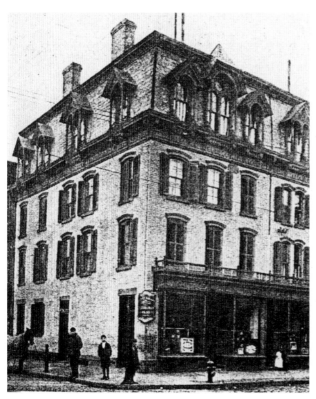

Left: Metz's Hotel. This hotel was once one of the most popular hotels and restaurants in the Middlesex County area. Built about 1859 on the corner of Neilson and Richmond Streets, this large structure remained standing until about 1930. It was begun by John Weigel, who quickly sold off his interests here and opened several other important businesses in the city.

Below: Jacob Reed fish market, 1914. By 1914, nearly all of the city's streets were paved with brick and edged with sidewalks, which made getting around a little easier. One place people liked to get around to was the old Reed Fish Market. For sale in this small building were all varieties of the freshest seafood, such as swordfish, scallops, shrimp, and haddock. The aisles were lined with large ice-filled bins to hold all of these types of fish.

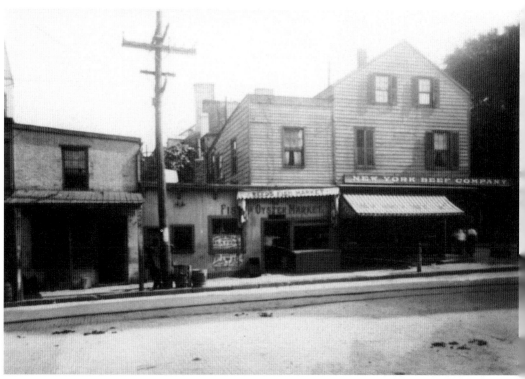

Right: Fredonian office, 1890. From 1811 until 1900, the daily and weekly *Fredonian* was one of the finest newspapers in the city. Begun by the Randolph brothers in April 1811, the paper was bought by editor John F. Babcock in 1854. Babcock shaped the paper into a fine, accurate source of local news through his own hard work. By 1900, the paper was sold, and in the 1901 publication ceased production.

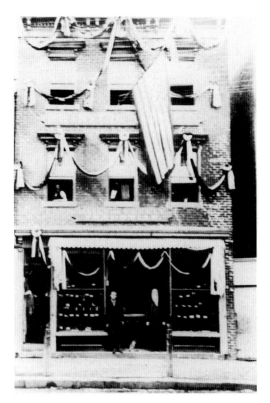

Below: Aerial view, 1884. On July 30, 1884, architect George K. Parsell climbed 140 feet to the top of the Reformed Church spire with a 6-pound camera. Standing on a spot only 2-by-3 feet, Mr. Parsell took a series of seven panoramic photographs that would later sell for 75¢ each or $3.50 per complete set. Mr. Parsell's photographs—the first aerial shots ever taken in New Brunswick—illustrate the oldest part of the city. This one looks toward George Street over the Bayard Street School.

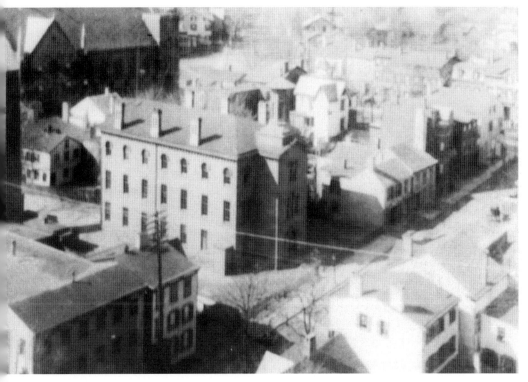

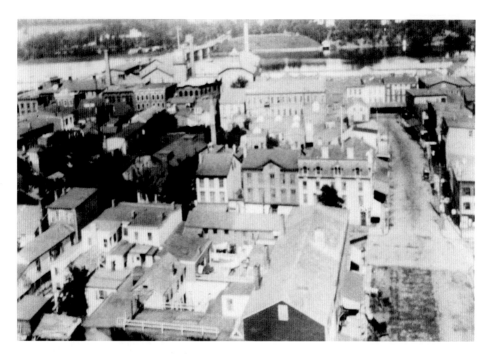

Looking toward Highland Park. This view shows the large Burnet Street business district as it appeared in the nineteenth century. Sadly, every structure in this view has been demolished. Some early eighteenth and nineteenth-century dwellings were combined in this area, and all stood side by side until 1951.

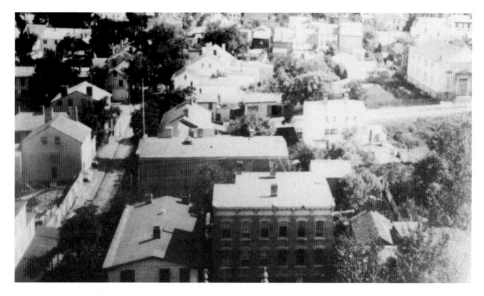

Looking toward the south. To the extreme right is the Methodist church, which was built in 1836 on Liberty Street to replace one destroyed by an 1835 tornado (the church building was replaced in 1876 and was later used as a warehouse). The "great tornado" of June 19, 1835, brutally ravished this area. Within twelve minutes of the tornado's arrival, over two hundred buildings had been demolished and three people—including one young child—had been killed.

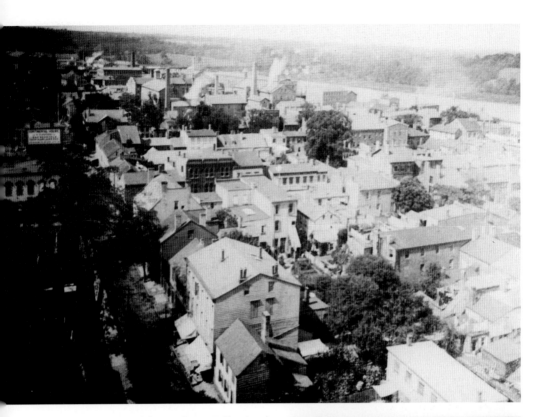

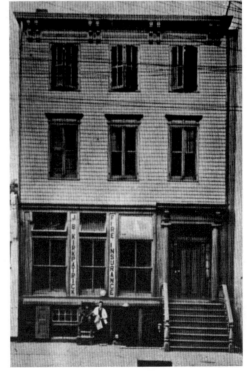

Above: Looking toward the northeast. Following the roof lines to the north we observe a rapid transition from areas of residential/commercial buildings to a smokestack-laden industrial park. Many of the city's industries were located north of Albany Street along Water Street. These included The New Brunswick Gas Light Company, The Empire Machine Works, and The New Brunswick Rubber Company. Small and large factories stretched all along Water, Washington, and Catherine Streets. The last trace of this area disappeared by 1980.

Right: Kirkpatrick building, *c.* 1910. The ravages of time took their toll on this house, which was remodeled in 1871 for commercial use. Mr. J. Bayard Kirkpatrick's office represented over twenty fire insurance companies and was the largest in the city.Mr. Kirkpatrick also sold real estate from this office, which was located at 356 George Street.

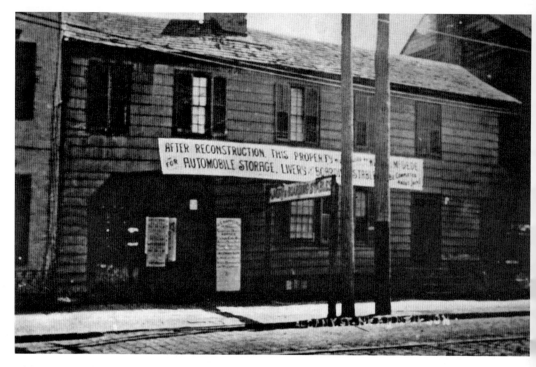

Old Dutch homestead, *c.* 1800. A sagging roof line is a telltale sign of this structure's true age. Built during the late 1700s to early 1800s, this homestead contained a massive center chimney and no less than four fireplaces. It stood on Albany Street near Neilson and originally adjoined Cochrans Tavern (see p. 10). At the turn of the century, the building was being remodeled into a livery stable. By 1930 it was removed due to its serious state of deterioration.

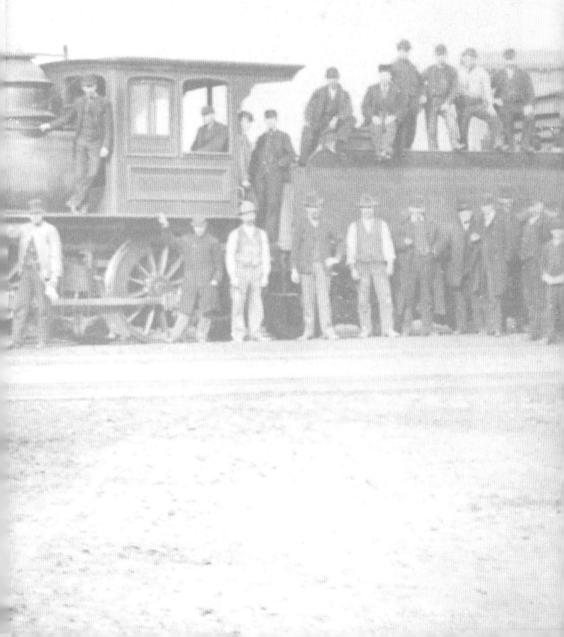

seven

Life in the Hub

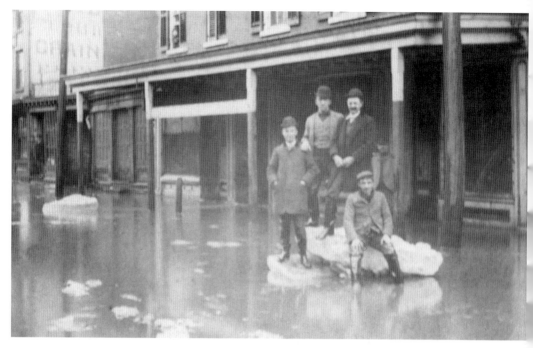

Burnet Street during the flood of 1890.

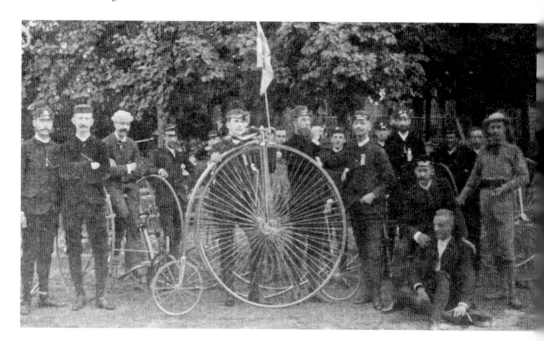

New Brunswick Cycle Club, *c.* 1890. All those interested in riding the "big wheel" met on the second Tuesday of each month at the Masonic Hall . Organized on May 1, 1882, this group of city residents would spend spring days tooling around the city, dazzling children and trying to win the hearts of young women along Albany Street. Comprising mostly Rutgers students and young businessmen, this group remained active until about 1920.

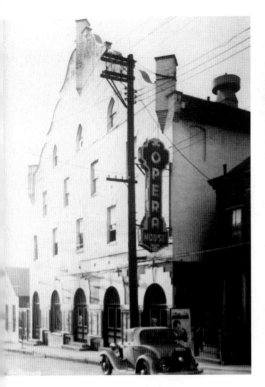

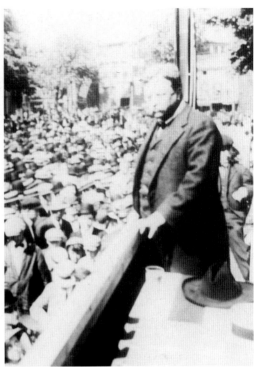

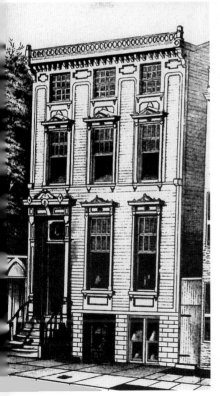

Above left: Opera House, *c.* 1936. After fire destroyed the city's opera house in 1896, a new spot was sought for city performances. Over twelve hundred persons could sit in luxury in this theater, which was located on Liberty Street on the site of the Methodist church. During its heyday, the Opera House hosted all the best traveling shows. After vaudeville acts were replaced with "talkies," the Opera House was reconstructed to show movies. Later it was closed and was demolished around 1960.

Above right: President Theodore Roosevelt, 1912. President Roosevelt visited New Brunswick in 1912 to speak on behalf of the women's suffrage movement. President Roosevelt is one of the four Presidents whose faces are emblazoned on Mount Rushmore; three of the four memorialized there—Lincoln, Washington, and Roosevelt—visited this little city on the river. Here, President Roosevelt is seen speaking on Livingston Avenue near George Street.

Left: New Brunswick Club, *c.* 1890. The New Brunswick Club acted much like an early chamber of commerce, promoting the city and keeping the history and records of important events in a small archival library. They worked out of this building on Albany Street near George Street at the turn of the century. During that time, officers of the club included Charlie Cowenhoven (president), A. Kirkpatrick Cogswell (vice president), and P. Vanderbilt Spader (treasurer).

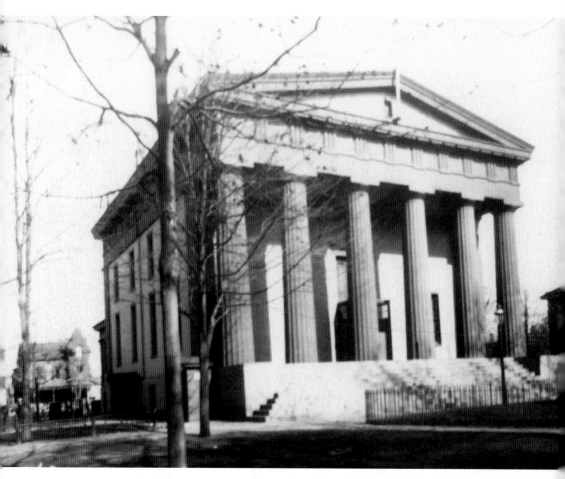

Middlesex County Courthouse, c. 1839. This massive, temple-fronted Greek Revival structure stood on the site of the present courthouse and was erected in 1839. It occupied the block of Bayard, Paterson, Kirkpatrick, and Elm Row, and was completed at a cost of $40,000. Built of brick with a base of blue granite, it was heralded as being "airy and open" when constructed. Soon, however, some complained that the building seemed cold and drafty. All offices connected with the county judicial system were housed here and the old courtroom offered plenty of seating room even for the biggest of trials. By the 1940s the structure was over a century old, and was soon replaced by a more modern edifice.

Opposite: Courthouse and sheriff's house, c. 1845. To the east of the old courthouse stood the sheriff's home, office, and the county jail. It was behind this edifice that public executions of the nineteenth century took place. Among those hanged here were John Fox, Joseph Williams, Michael Sullivan, Frederick Lang, and most notoriously, Bridget Dergan. On Friday, August 30, 1867, twenty-two-year-old Dergan was executed for the murder of Mrs. Coriell of New Market. Dergan was a servant of the Coriell family who reportedly attempted to become closer to the doctor of the house by removing his wife. Although she pleaded not guilty, she was hanged here. Dergan was the last woman in New Jersey to meet her demise in this manner.

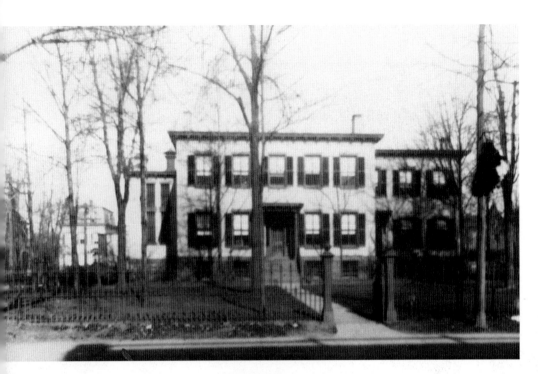

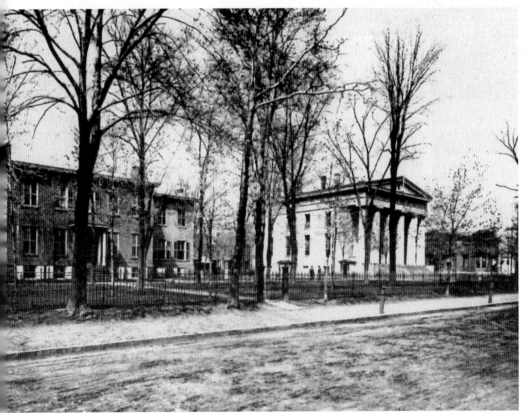

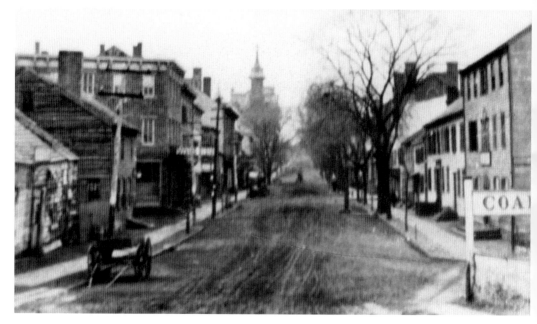

Albany Street Bridge, 1870/1935. In the sixty-five years that passed between these photographs, many changes took place along Albany Street. On the left in the 1870 view (top photograph), an old Dutch frame house stands at the foot of the bridge. By 1930 this spot was occupied by a diner and an Esso service station. The Second Reformed Church, along with many other buildings on Albany Street, had recently been razed in the 1935 view (bottom photograph). However, the old Jackson House was rebuilt as the Hotel Klein. The coal yard remained intact for almost one hundred years, as did the Farquhar House on the corner of Albany and Water Streets (see p. 13).

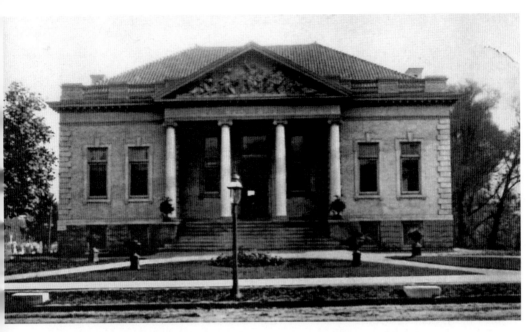

Free Public Library, 1902–03. In 1902, Andrew Carnegie presented New Brunswick with a proposition. He offered to donate $50,000 for the erection of a new library building if the City would agree to support the institution with $5,000 annually for operating expenses. Oddly, the City agreed to Carnegie's idea, but the library board opposed it. After a bitter controversy, the building was constructed on Livingston Avenue near the corner of Morris, at a final cost of $51,287.51. The site was once occupied by the city roller-skating rink, which was demolished in 1899. The library still stands proudly, with a large addition that was put on in 1993. Its interior has been only slightly altered through the years, and the classic turn-of-the-century building is worth a visit.

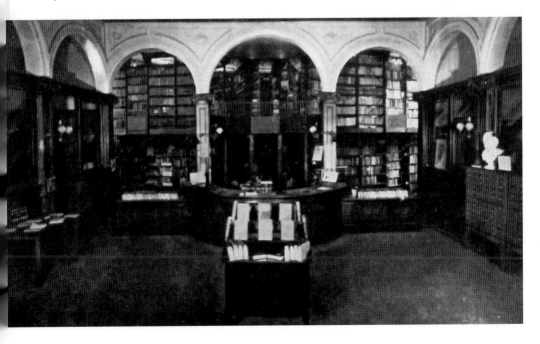

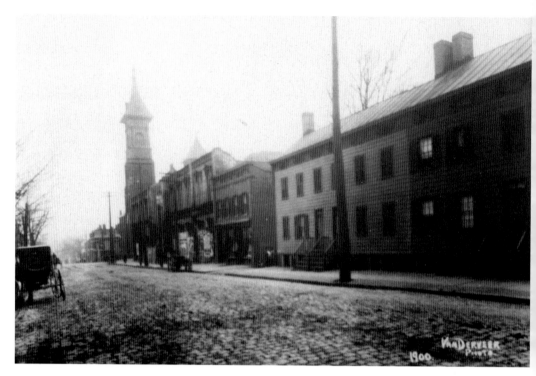

Above: Albany Street looking toward George Street, *c.* 1900. New Brunswick contained a large number of wood frame row houses that were modeled after those constructed in Manhattan in the late 1700s. During the period from 1750 to 1820, nearly all of this street was inhabited by Dutch settlers. In later years, many of these dwellings were remodeled for commercial purposes; they had all but disappeared by 1950.

Left: House moving, *c.* 1902. Moving a house in the days before hydraulics was no easy task. The work involved jacking up each area of the house with a large screw jack and slowly sliding wood cribbing underneath the structure. Finally, the building would have new floor beams installed, and the area's largest horse teams would pull the house slowly to its destination. This row house was moved shortly after the photograph at the top of this page was taken.

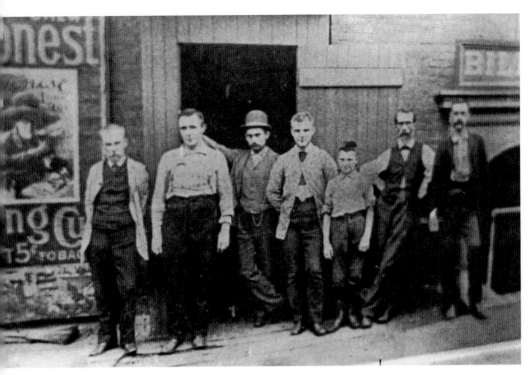

Above: Post Office staff, 1888. During New Brunswick's early years, the post office moved frequently; by 1884 it had been moved ten times. In 1885, the office moved to the Masonic Hall at George and Albany Streets, where it remained until 1892. Originally mail was only delivered in decent weather when the roads were in passable condition. Until the mid–1800s, all mail was delivered at a cost of 1¢ per letter.

Right: YWCA, *c.* 1925. The Young Women's Christian Association was formed about 1900 as the first "equal opportunity" club for city ladies. Membership was open to all women of good moral character without reference to religious beliefs. This building, which stood on George Street, was equipped with social parlors, lecture rooms, and a small reading library. Annual dues varied but usually ranged in the $2 to $3 range, depending on one's social status.

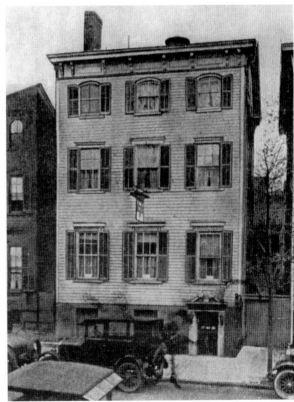

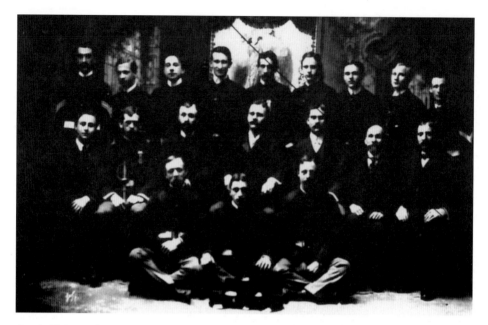

Goodwill Council No. 32, *c.* 1895. The Goodwill Council was one of several city chapters of the United American Mechanics. This chapter was organized in May 1872 with twelve charter members. Meetings were held every Monday evening at Mechanics Hall, which was located at the corner of George and Church Streets.

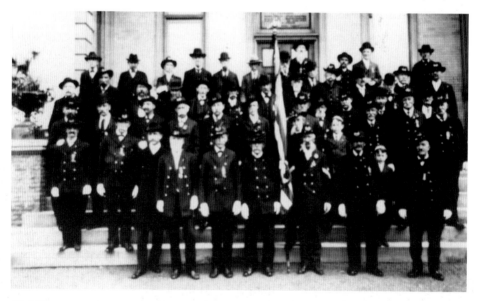

Civil War veterans, *c.* 1905. Posing proudly on the steps of the new city library are city veterans of the Civil War. During the war, the city's men were represented in every branch of the service, including the infantry, calvary, artillery, and the signal corps. In all, 783 men from New Brunswick fought in the war. Among them were several colonels, one general, and many captains and other officers. In 1930, the veterans of the Civil War in New Brunswick numbered only around fifty.

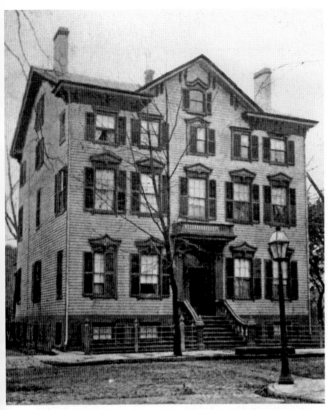

Left: Misses Anable's School, *c.* 1900. After the closing of Miss Hannah Hoyt's school in 1871, the young ladies of the city were in dire need of a new place for education. So in 1872, Miss Anable opened her seminary at 66 Bayard Street. In this edifice, young women were schooled in etiquette as well as a variety of core disciplines. The school itself was opened in one of the finest frame mansion houses in the city. It was demolished by 1950.

Below: View of New Brunswick, *c.* 1840. This scene was reproduced from an early city bank note. In 1840, New Brunswick had a population of nearly seven thousand and had become a thriving transportation center. The canal was prospering, the railroad was running daily, and hundreds of wagons entered onto the steamboat dock each day. Looking down from Sonomans Hill, we can see an old side-wheeler heading down the river to New York City with a load of freight and passengers.

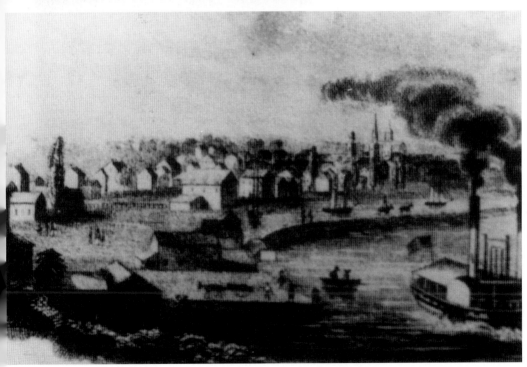

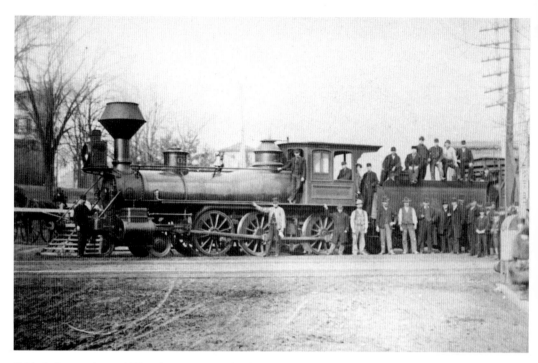

Baldwin locomotive, *c.* 1885. This is an example of the ten-wheelers operated by the railroad during the last half of the nineteenth century. This one is waiting on the approach at the George Street crossing. Behind the engine's stack the home of the Rutgers University president can be seen, and behind the tender is the Protection Engine Company. Notice the raised crossing gate and the "hands off" painted boldly upon it. This crossing vanished when the railroad was elevated in 1902–03.

George Street depot, *c.* 1838–39. The first depot constructed by the New Jersey Railroad and Transportation Company was opened in 1839. Among the first railroad stations built in America, it was constructed from pieces of the old Baptist church that had stood on the site since 1836. This frame structure was remodeled in 1885 and razed in 1902 when the new station was finished on Albany Street. The site is now part of the Johnson & Johnson complex.

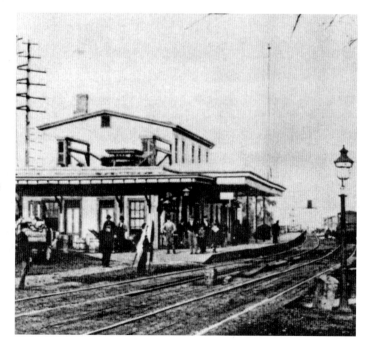

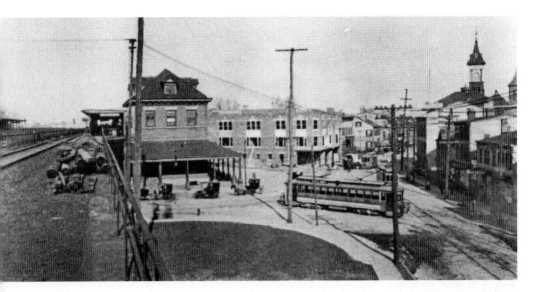

Pennsylvania Station, *c.* 1903. In 1903 the railroad began construction of a new passenger station on Albany Street at the corner of Easton. This multi-level building was designed as part of the new elevated track system. The new elevated system produced fewer traffic tie-ups. The station is now part of Amtrak's northeast corridor line, and thousands of commuters still wait at the platform every morning to ride trains to work.

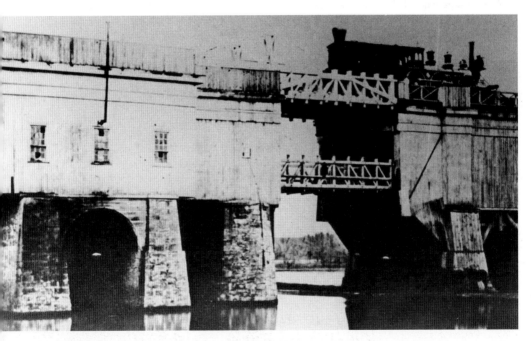

First railroad bridge, 1837–38. Erected by the New Jersey Railroad and Transportation Company in late 1837, this became the first bridge to carry trains over the Raritan River. Its structure was unique because the lower level was designed for horse and wagon travel. The bridge cost $57,532 to complete, and on March 9, 1878, it was completely consumed by fire. The locomotive seen here is of the earliest type and includes a rarely photographed enclosed tender.

Raritan River railroad depot, *c.* 1890. By the early 1970s the old depot of the Raritan River line was vacant and awaiting demolition. Built in 1890 to serve the newly opened line that ran from Milltown to New York City, it was typical of many small town stations built during the latter half of the nineteenth century. During World War I it was the point from which soldiers could depart free of charge. Its interior included wainscoted walls, a tin ceiling, and a small office and waiting room. By 1976 it had been demolished.

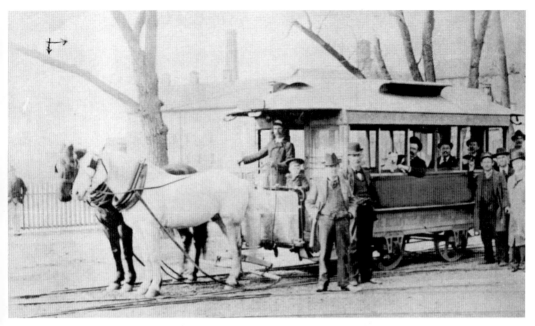

Trolley cars, 1895. The first horsecar tracks were laid in 1884 and officially opened on October 14, 1886. During that time every structure in town was decorated with colorful bunting to celebrate the occasion and the entire city turned out for the celebration. The tracks commenced on Somerset Street and then ran to Commercial Avenue, Sandford Street, Throop Avenue, and George Street, across Huntington and across to St. Mary's Home. In 1895 the line was electrified and purchased by the Brunswick Traction Company. About 1906, the Public Service Corporation took over and the last cars ran in 1917. The last tracks were removed on Joyce Kilmer (Codwise) Avenue in 1930. The line later became the route of the Grey Bus Line, which ran to South River.

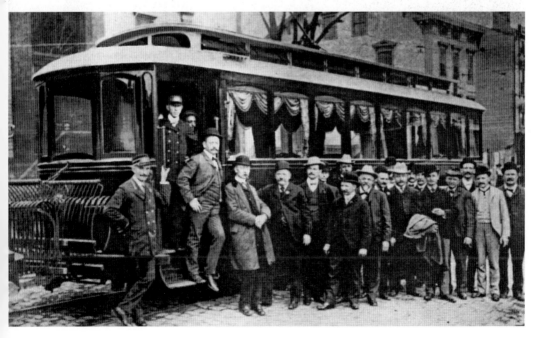

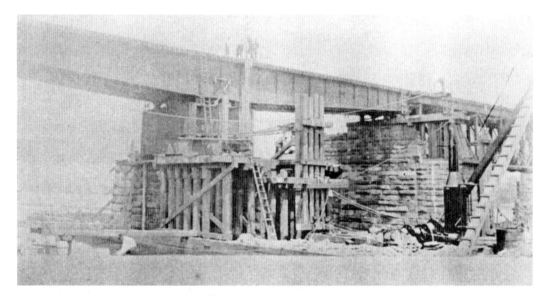

Steel railroad bridge, *c.* 1879. After the wooden bridge was destroyed, a steel girder bridge with a swing draw was erected. In 1902, preparations were made to move the entire bridge 14.5 feet south in order to construct the present stone arch structure. Incredibly, after months of work, the steel bridge—weighing 1,836 tons—was moved in ten-and-one-half minutes. One of the seven steam engines used to move the structure can be seen on the right.

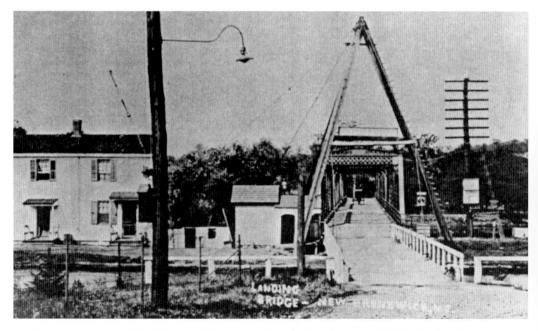

Landing Lane bridge, *c.* 1894. This steel bridge was built to replace the covered bridge that was burned in 1894 (see p. 24). In the foreground, an A-frame structure appears that was actually a separate drawbridge over the Delaware and Raritan Canal. The Landing Lane bridge was extensively rebuilt in the early 1990s, at which time the steel superstructure was removed. The canal bridge and the bridge tender's house were also removed.

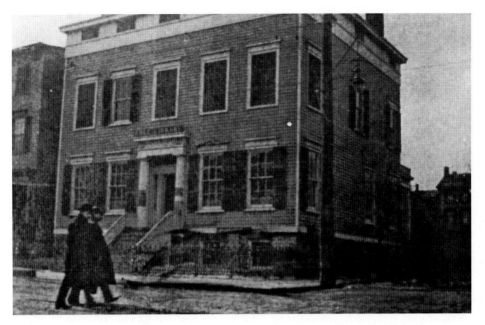

Fourth Library, c. 1895. From June 1892 until November 1903, this old house was home to the free library. This Greek Revival edifice was constructed about 1841, and was located at the corner of George and Paterson Streets. It was later moved to a lot further up Paterson Street, but eventually was demolished.

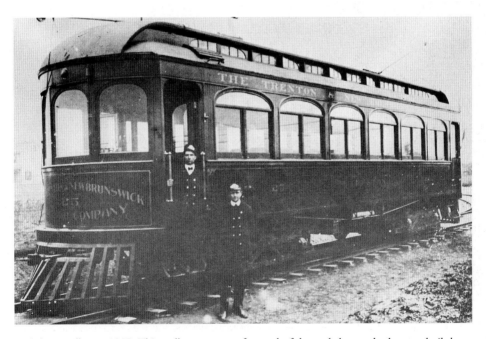

End door trolley, c. 1915. This trolley was one of several of the end-door style that was built by the Brill Manufacturing Company. Many improvements had been made in riding conditions since the first horse-drawn cars appeared in 1884. Among the new conveniences were electric heat, softer seats, and more time-efficient transport.

State Theatre, *c.* 1920. For most of the twentieth century, the State Theater was the finest motion picture house in the city. Constructed in the Beaux Arts style, this edifice was a typical example of a 1920s theater. By the late 1970s, it had fallen into disrepair, but it was included in the revitalization of the Livingston Avenue/George Street area. Today the State Theater is operated as a stage center for many fine theatrical productions.

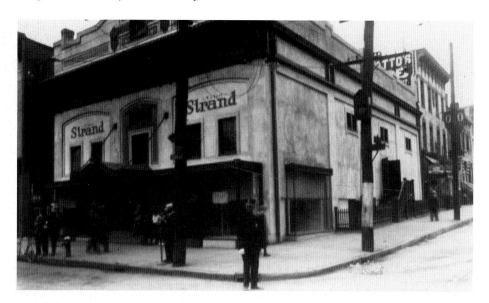

Strand Theatre, *c.* 1905. Located at the corner of George Street on Albany Street, the Strand was one of the first twentieth-century theatres in the city. In 1905, the K, S & K Amusement Company purchased the German Reformed Church (see p. 66), and quickly remodeled the structure. The pulpit was removed and a large stage was added, and the exterior received a masonry stucco job. This structure outlived many of the buildings built in 1840; it was finally demolished *c.* 1965.

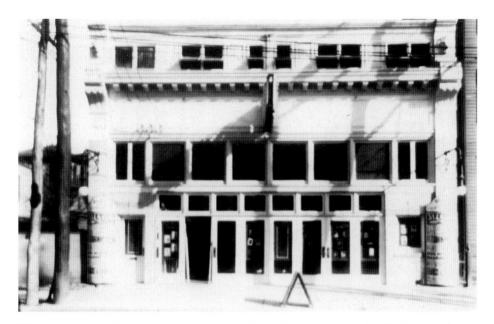

Bijou Theatre, *c.* 1906. Over seven hundred people could enjoy the finest vaudeville performances in the George Street Theatre. Shows were held twice daily, once in the afternoon and then again in the evening. In later years, a marquis was added to display the latest movie titles. The building was razed *c.* 1965.

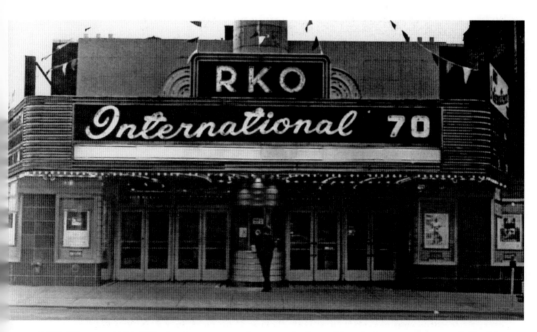

RKO Theatre, 1936. This Art Deco masterpiece was the last of the city's great theatres to be built. It could comfortably seat 1,030 people and was located at the foot of Albany Street near the bridge. It was renamed the International Theatre in 1972; in 1978, preservationists lost their battle and the edifice was demolished.

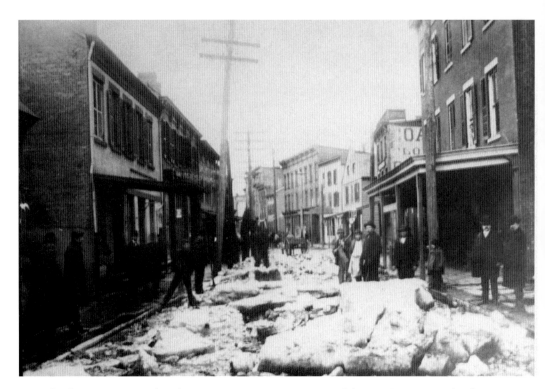

Great floods. On an average day, the Raritan River moves at a rate of about 700 to 1,000 cubic feet per second. At 7,000 cubic feet per second the riverbanks are full, and speeds faster than that produce what is regarded as a freshet. In the early years, the entire lower portion of the city was prone to flooding. Floods could occur in winter or summer. Winter storms were especially dangerous because structures were heavily damaged by large ice flows. The flood in 1920 caused the most damage, necessitating $250,000 worth of repairs.

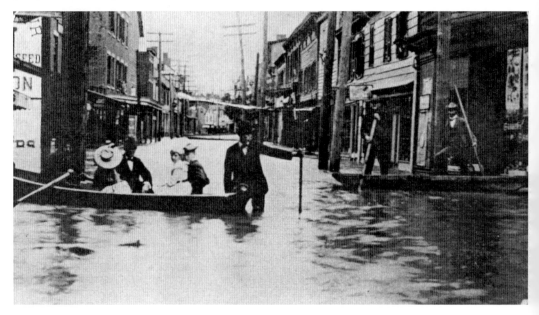

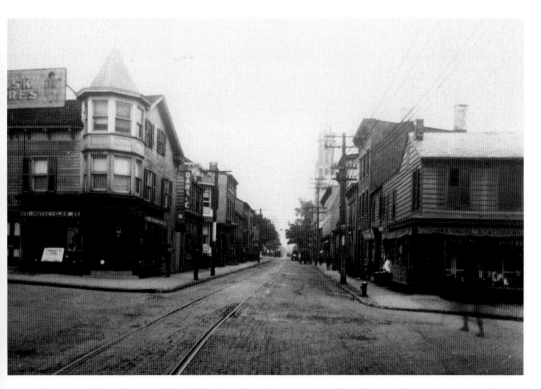

George and New Streets, 1920/1936. Isaac Vanderveer captures the changes that a city sees over the years. There is a time span of sixteen years between these photographs. Several of the buildings in the 1920 photograph (above) were demolished by the time the 1936 photograph (below) was taken, and a new hotel appears in their place. Cobblestone roads and trolleys gave way to sedans and pavement within this time span.

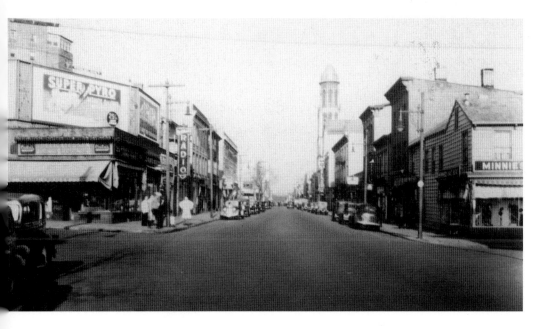

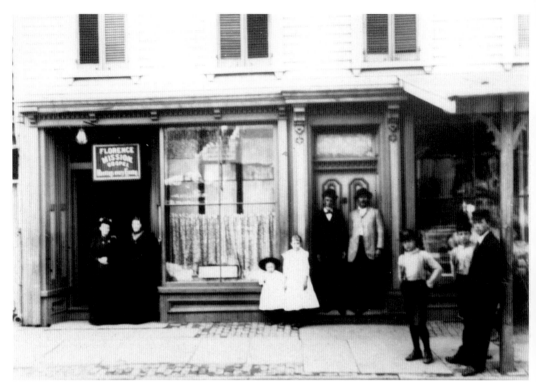

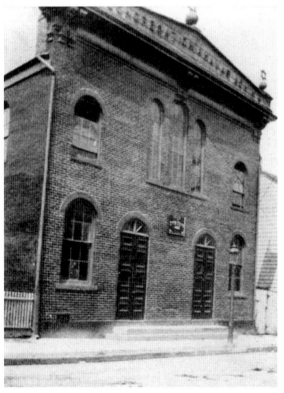

Above: Florence Mission, *c.* 1890. Established in 1890, the Florence Mission Gospel served the lower city area as an unstructured, non-denominational church. Located on Burnet Street in an old storefront, the mission was patronized mainly by women. This mission and several others were all well-attended in the late part of the nineteenth century by people seeking an alternative place of worship.

Left: Salvation Army building, *c.* 1860. The Salvation Army, formed before the Civil War to assist the city's poor and suffering, stood on Richmond Street, halfway between Dennis and Neilson. In 1910, the building was purchased by the congregation of Temple Ahavis Achim. Several other historic buildings stood on this block, including the Temperance Hall, Turns Hall, the Phoenix Engine House, twelve private dwellings, and several stores. By 1980 this entire block had been removed for urban renewal.

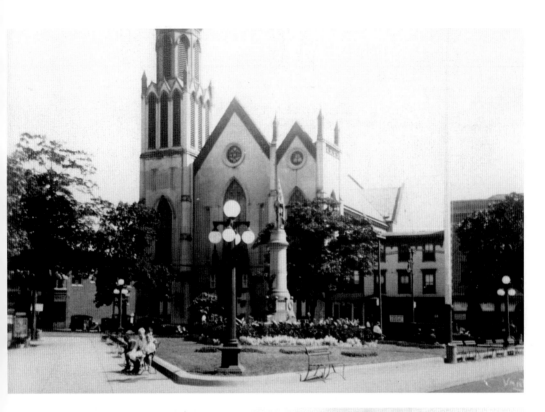

Above: Monument Square, 1935. Made up of the intersection of George, Livingston, and Schureman Streets, this square is actually a triangle. In the early 1820s, this block was occupied by several storehouses and homes, all of which were destroyed in the 1835 tornado. Later, the Second Presbyterian Church built a house of worship here that occupied the block until 1876. After several years of vacancy, the square became home to a Civil War monument in 1894; since that time the area has remained a park.

Left: Hiram Street in 1870. Standing at the corner of old Burnet Street looking up Hiram, we can see many of the old structures that once stood along this roadway. In 1876, most of the buildings would be demolished for the widening of this street. From 1811 to 1865 the city market occupied this spot (see p. 23). Today only the Reformed Church remains and the area is dotted by some tastefully reconstructed Federal townhouses.

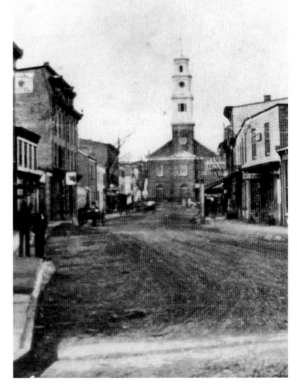

Burnet Street 1951/1978. By 1951 (above), lower New Brunswick was a prime example of urban blight. Empty buildings and abandoned cars were all that remained when the city gradually moved its business district uptown in the 1920s. The Agnew house (see p. 31) and the quarters of the Washington Engine Company remained standing, but would soon meet the wreckers' ball. By the early 1970s (below), the only buildings that remained—a 1920s store and a nineteenth-century farmhouse—had been vacated and soon another highway project would result in their demolition.

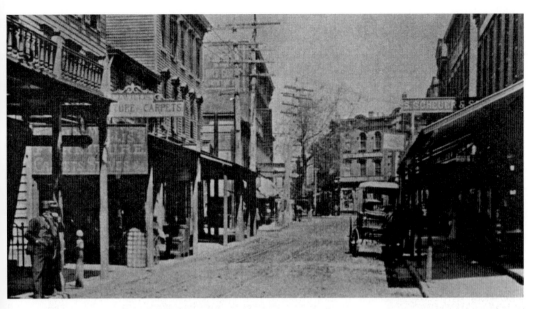

Burnet Street, *c.* 1889. Looking toward the Stout Building in Commerce Square, we can feel the importance of this area. Wagons and busy stores lined the area and merchants and shoppers dotted the streets selling and buying wares. On the right is Greers Hall (p. 26), which was now being used as a grocery store. This area is now Route 18 near the city police headquarters.

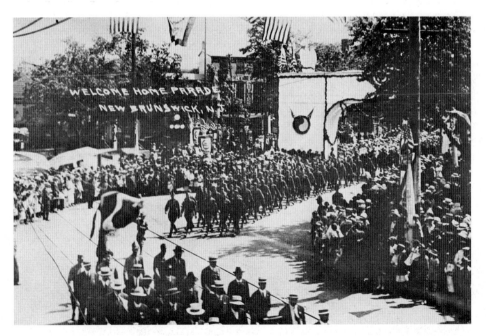

Welcome home parade, 1919. It was on the eleventh hour of the eleventh day in November of 1918 that the big guns fell silent marking the end of World War I. After months of planning, the big welcome home celebration was ready. Over eight hundred veterans marched through the city streets, and countless "Welcome Home" banners flew from every window in the city. Here the men of the 78th Regiment round the corner on Livingston toward George Street.

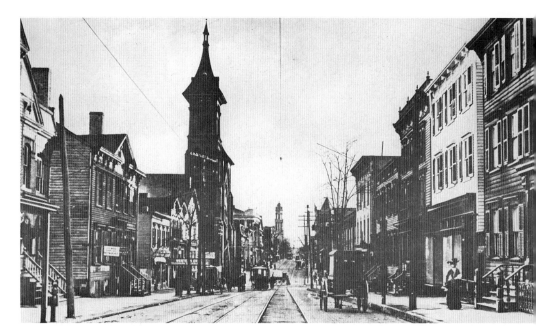

George Street, *c.* 1890. During the latter half of the nineteenth century, George Street, which had been primarily residential, slowly grew to become city's principal commercial district. From Hamilton Street to Albany, the early transition is apparent as many new signs and store fronts can be seen to emerge. All of these structures have been demolished and the site is now home to Johnson & Johnson's headquarters. Note the trolley tracks and the overhead electric wiring.

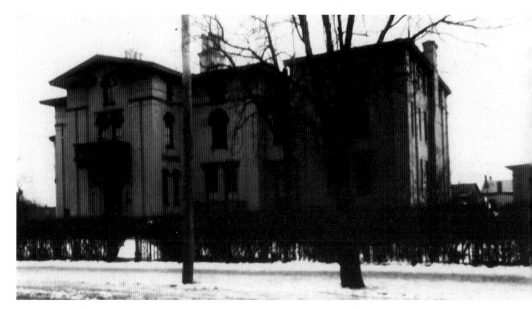

Children's Industrial Home, *c.* 1885. This school was a direct descendant of the old Lancasterian School (see p. 38), and was funded by the overseers of that school after it closed in the 1850s. The fanciful structure stood on Somerset Street near Prospect Street until about 1960. In later years a large addition was put on the left of the structure to accommodate a growing enrollment.

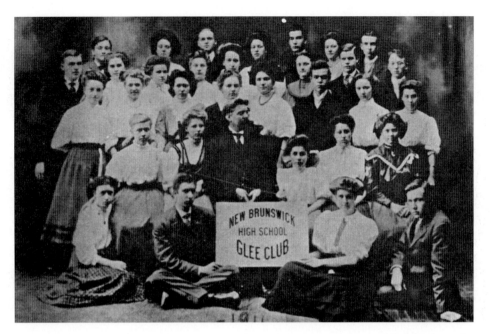

New Brunswick High School Glee Club, 1911. The old Livingston Avenue High School was the site of this photograph, which was taken in the school's gymnasium. Glee club members were kept busy during recitals and especially over the holidays singing and entertaining students. This group included sopranos, altos, tenors, and baritones. The director is pictured in the center.

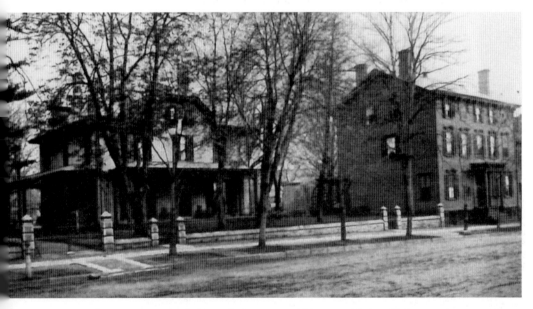

Janeway residences, c. 1900. Both Henry L. Janeway and his son resided on Livingston Avenue with their families at numbers 11 and 17. Henry Sr. played an active part in organizing the New Brunswick Water Company in 1859. In later years, Mr. Janeway and his family operated one of the city's most prosperous industries—Janeway and Company, located on Water Street along the canal. The houses themselves dated to the late 1840s and were among the finest in the city.

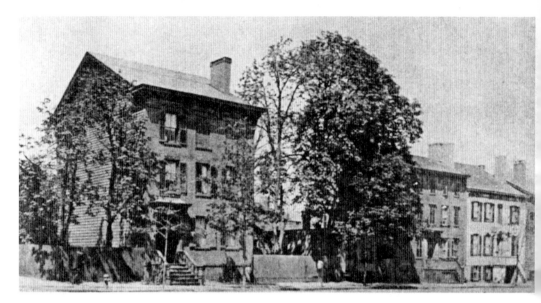

Albany Street near Easton Avenue, *c.* 1900. These houses stood on Albany Street until 1903, when they were demolished by the Pennsylvania Railroad to build the new depot. The fine three-story house on the corner of Albany and Easton was built about 1820 by Rutgers professor J. Nelson. During the early years this area was several blocks from the business district and afforded citizens a good quiet neighborhood for raising families.

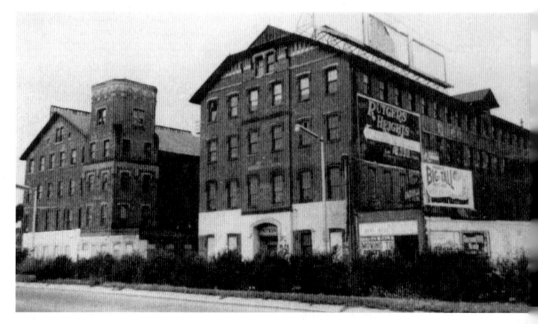

Water Street factories, 1970. During much of the nineteenth century Water Street was lined with a large amount of industry. Located in this area were Janeway and Company, the Garretson Bowne Company, and others. Built between 1878 and 1888, the above buildings were home to the Empire Machinery Works, founded around 1870. Industry was located here as early as 1815. This area remained mostly intact until it and Water Street itself disappeared in the path of Route 18 construction.

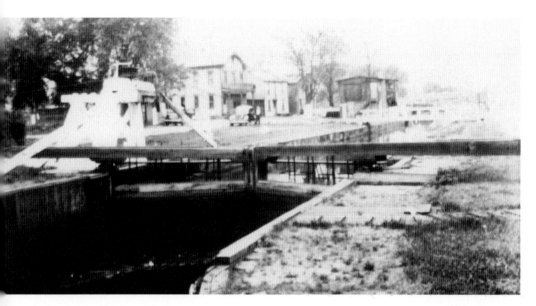

Delaware and Raritan Canal. Construction of the Delaware and Raritan Canal began in 1830. This great industrial waterway was dug from Trenton to New Brunswick to link the Delaware River with the Raritan, in order to increase the speed of moving cargo, especially coal. The 93-mile strip was completed in June 1834 by thousands of immigrants, most of whom were Irish. The canal began at the foot of Burnet Street past the steamboat wharf where Lock #1 was built in 1833 (above). It next passed through the city until it exited into Franklin Township past the Landing Lane bridge and continued west. By 1927, canal trade had considerably decreased. This was due in part to the canal becoming silted, and also to an increase in truck travel. The canal finally closed around 1930. Most of it today is a state park.

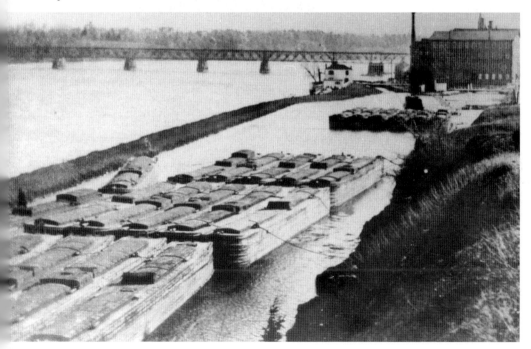

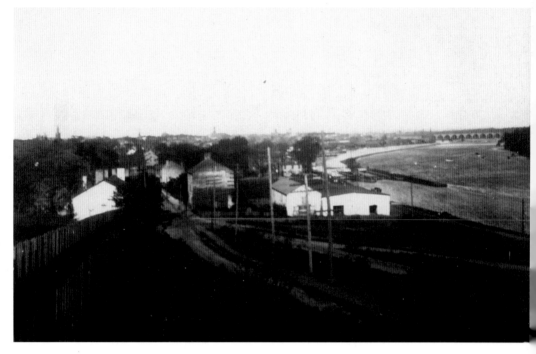

Burnet Street, 1909/1989. The final images that appear here were chosen to represent the dramatic changes that have occurred in New Brunswick in the last century. Both photographs were taken from the vicinity of Sonomans Hill, looking north on Burnet Street. It is amazing how entire neighborhoods and even portions of a city can disappear without a trace. When we travel on Route 18 today, we should appreciate what was here before, and the lives of those who lived and prospered within our community.